IMAGES OF A GOLDEN ERA

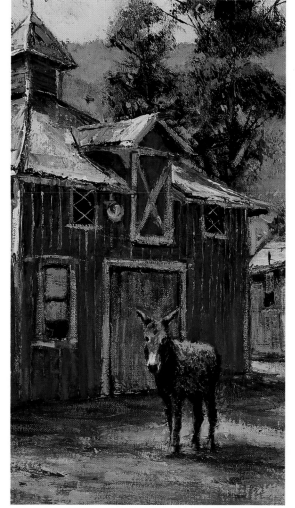

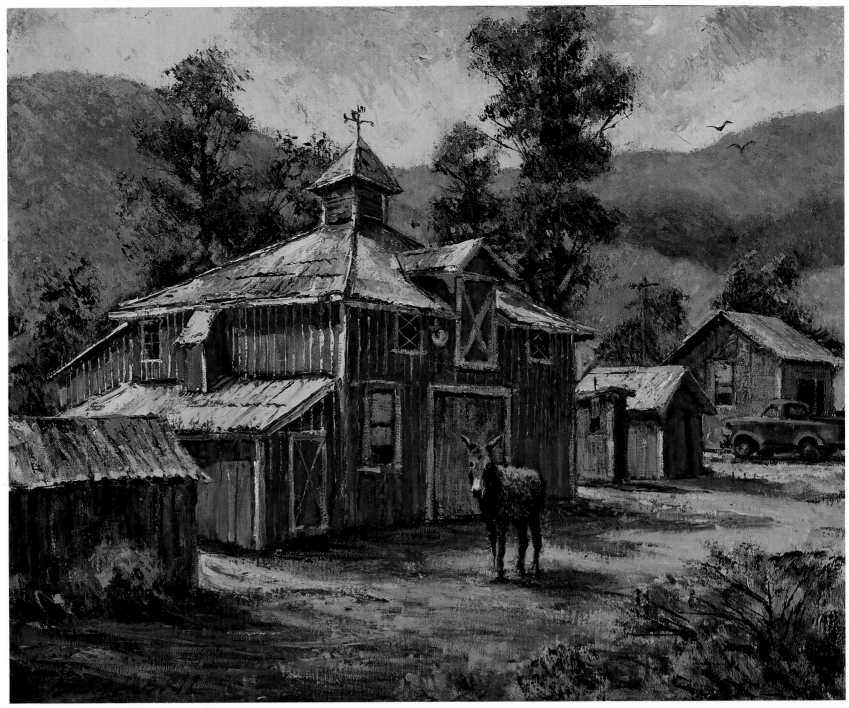

"Willie," at the Old Mentryville Barn

IMAGES OF A GOLDEN ERA
Paintings of Historical California

by
BEN ABRIL

Introduction by
LEON G. ARNOLD

Editing and Biography
JANE NAPIER NEELY

Layout and Design
ERNEST MARQUEZ

THE ARTHUR H. CLARK COMPANY
Glendale, California
1987

The paintings reproduced in this book
will be exhibited at the
Los Angeles County Museum of Natural History
900 Exposition Boulevard
Los Angeles, California 90007
February 3, 1987 through April 26, 1987
and at the
San Bernardino County Museum
2024 Orange Tree Lane
Redlands, California 92373
April 28, 1987 through June 14, 1987

Library of Congress Catalog Card Number 86-72442
ISBN 0-87062-174-2

THE ARTHUR H. CLARK COMPANY
P.O. Box 230
Glendale, California 91209

Dedicated to my wife Dorothy
and my mother Sarah, who encouraged
me from the beginning.

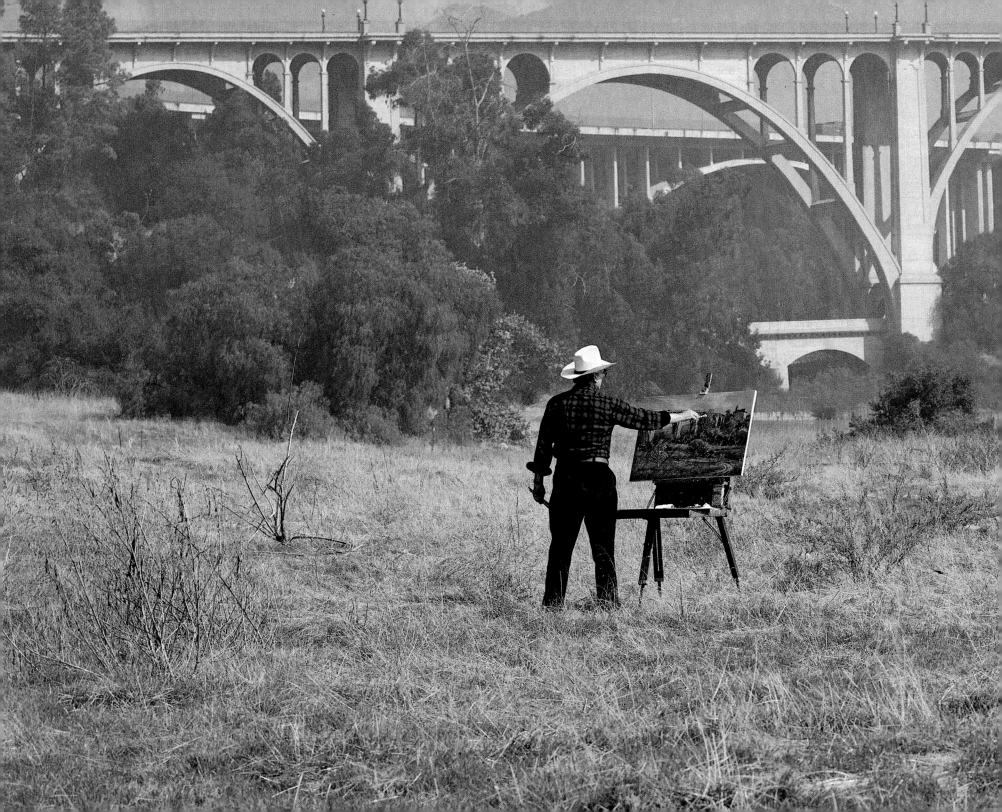

Landscape painting is my life.
The beauty of California is my inspiration...
I paint her ocean shores, along the inland
valleys, and the solitude of her
snow capped mountains.
— Ben Abril

Introduction

I have known Ben Abril for many years and regard him as an enthusiastic artist, a man of character and a sensitive person. He has always strived to create work true to his own ideals rather than be influenced by current trends. I respect his art and will always consider him a great friend.

He is a romantic painter with the ability to portray great feeling in his art and he creates a mood of ease and wonderment for the viewer. Abril's paintings are not contrived and have a refreshing directness in harmony with nature. He paints "en plein air" similar to the early American impressionists, William Merritt Chase and Childe Hassam. People like his works because they can relate to them. The scenes are of real places and give you a strong feeling of having been there before, along with a good sense of design and color. His canvases have an excellent textural quality due to his expert use of the palette knife.

In April 1969, the Los Angeles County Museum of Natural History presented a one-man show of his Bunker Hill Mansion paintings. This presentation attracted large crowds of both art lovers and historians. The area he depicted on canvas has since been torn down for the sake of urban renewal, but the paintings of Ben Abril will live on. It is no wonder that, at the close of the show, the museum purchased all thirty-six paintings for its permanent collection.

This latest collection of his paintings, depicting western historical scenes around his hometown in Southern California, contains some of his best work to date. They have an aesthetic quality as well as a historical tone. Many of the scenes are of ranches and locations used by William S. Hart, Tom Mix, Gene Autry, and others in the filming of early Hollywood western movies.

The historical information regarding the paintings was acquired, in many instances, from people living at the scene or from public library research. The information on historical monuments is from documentation by the State of California.

Abril's paintings are in many private collections and he has numerous awards to his credit. His works of art hang in seven museums, and he is listed in "Who's Who in American Art." The paintings shown here are collector's items and will preserve our American heritage long after the scenes are gone.

Leon G. Arnold
Assistant Director,
Los Angeles County Museum of Natural History

A Review

Ben Abril belongs to that small core of landscape painters who, in addition to painting what they see, capture on canvas the "feel" of a subject.

If he paints an oak tree in a dry stubble field sheltering cattle from hot California sunshine he gives us much more than the design of forms and colors and goes far beyond a report of merely visual experience. So engaged are his senses that his pigment seems mixed with the heat reflected from the dry ground, with the odors of dry grass, of oak leaves, of the milky smell of the lazy beasts. He feels the place so intensely that he is able to put us in it. He is so absorbed in the unconscious world of nature that he seems to be painting it, not as a spectator standing outside, but as one experiencing Nature from within.

This is rare in painting today. Artists, like the rest of us, are so fascinated by the unseen structure of nature that they often overlook the fact that we still live in the sense world. Design is necessary to life and art, but neither moves us unless it makes its appeal through our emotions.

Ben Abril has gone up and down California painting moments of nature-experience. Recently he has found fresh inspiration in the coastal regions of Mendocino County and among the old towns and sleepy gulches of the Mother Lode country where the Forty-Niners dug for gold.

Arthur Millier
The late Arthur Millier was a nationally respected art critic with the *Los Angeles Times* and the *Herald Examiner*.

The Paintings

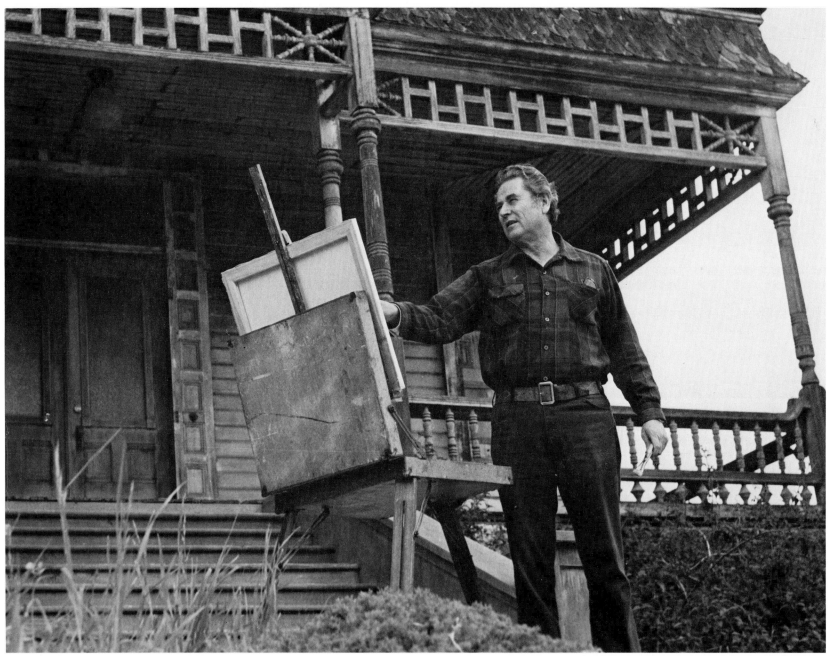

Ben Abril painting on Bunker Hill

Art and Commentary by Ben Abril

Willow Springs Stage Station

Built in 1864, this weathered building in the small town of Willow Springs was a stopping point for the Los Angeles-Havilah and Inyo Stage Lines traveling through Oak Creek Pass to the Tehachapi Valley. The stage line continued to make this run until 1872. Water flowing from natural springs, at the rate of 150,000 gallons per day, made the town of Willow Springs a natural watering stop. As early as the 1400s the area was a Piute Indian settlement. The springs were visited by the explorer Padre Garces in 1776. In 1844 General Fremont stopped here to rest and water his horses. The starving Jayhawker party found water here in 1850 while struggling from Death Valley to Los Angeles. In 1863, during the presidency of Abraham Lincoln, the 160-acre parcel of land that became Willow Springs was acquired by General Edward F. Beale. In 1976 a movie studio used Willow Springs as a setting for the movie, "Viva Evel," featuring the motorcycle stunt man Evel Knievel. Today, Willow Springs is virtually a ghost town with only 17 inhabitants.

(Oil 24" x 30")

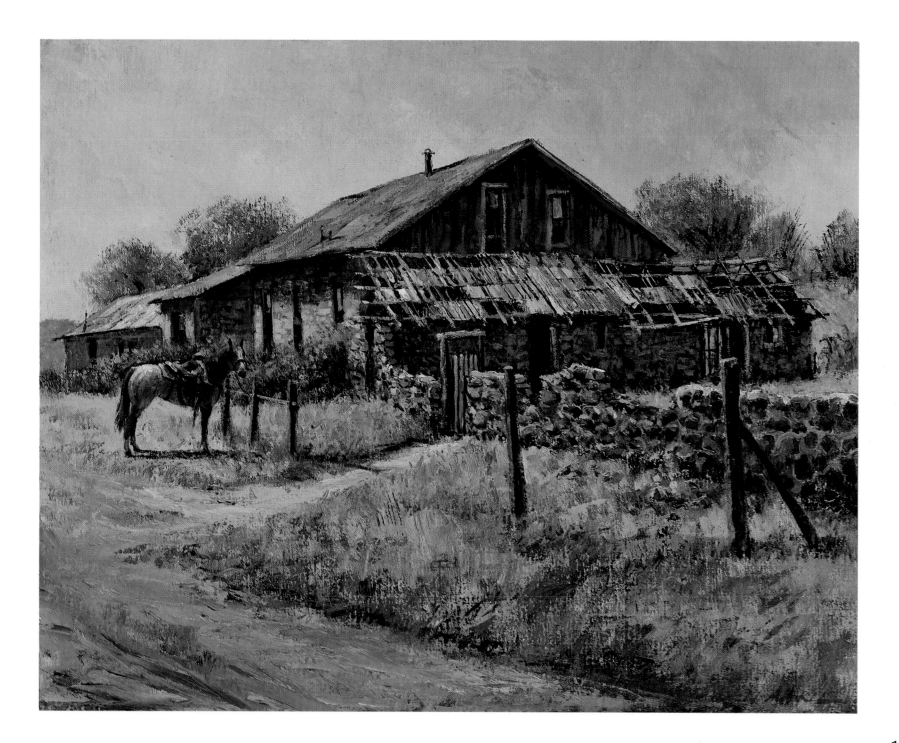

Our Lady Queen of the Angels

The Plaza Church, *la Iglesia Nuestra Señora de Los Angeles,* is the oldest place of worship in Los Angeles. In 1814, the building of the adobe block main chapel was begun by Franciscan Fathers and Indian neophytes. The people paid for the construction of the church by donating 500 head of cattle and numerous barrels of fine brandy. Dedication of the chapel was made in December, 1822. It was not part of the California mission system, but functioned as a church in the *Pueblo* of Los Angeles, so worshipers would not have to travel to the San Gabriel Mission. The chapel has a golden altar brought from Spain where mass is celebrated daily by Claretian Fathers. Hollywood motion picture studios often use the chapel for the filming of Christmas and Nativity scenes. In 1981 portions of the movie, "True Confessions," starring actor Robert Duvall, were filmed here.

(Oil 18" x 24")

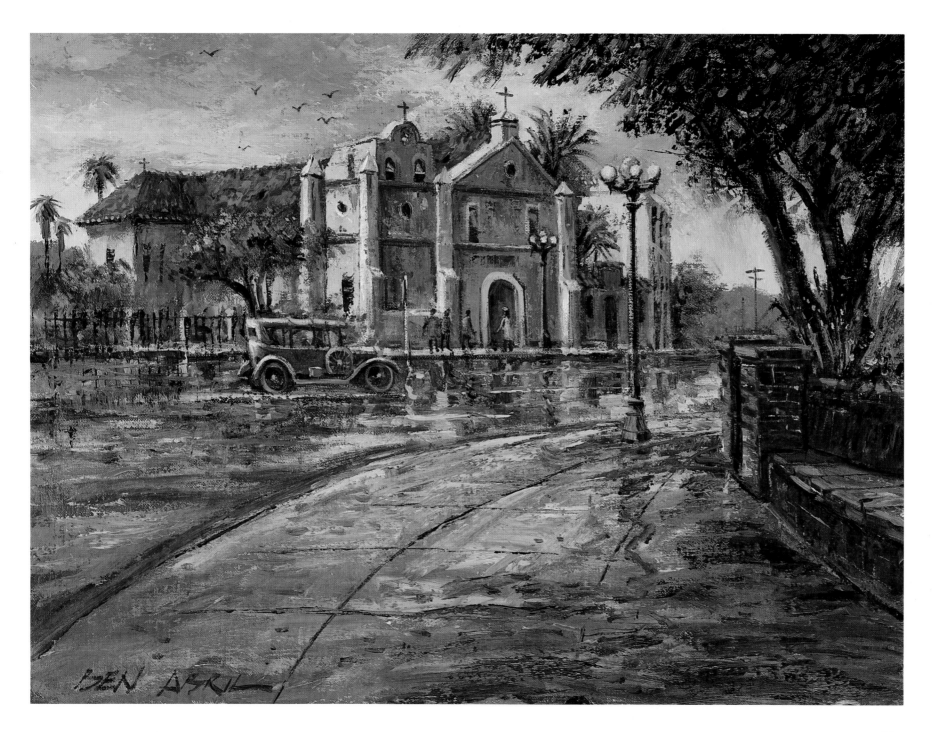

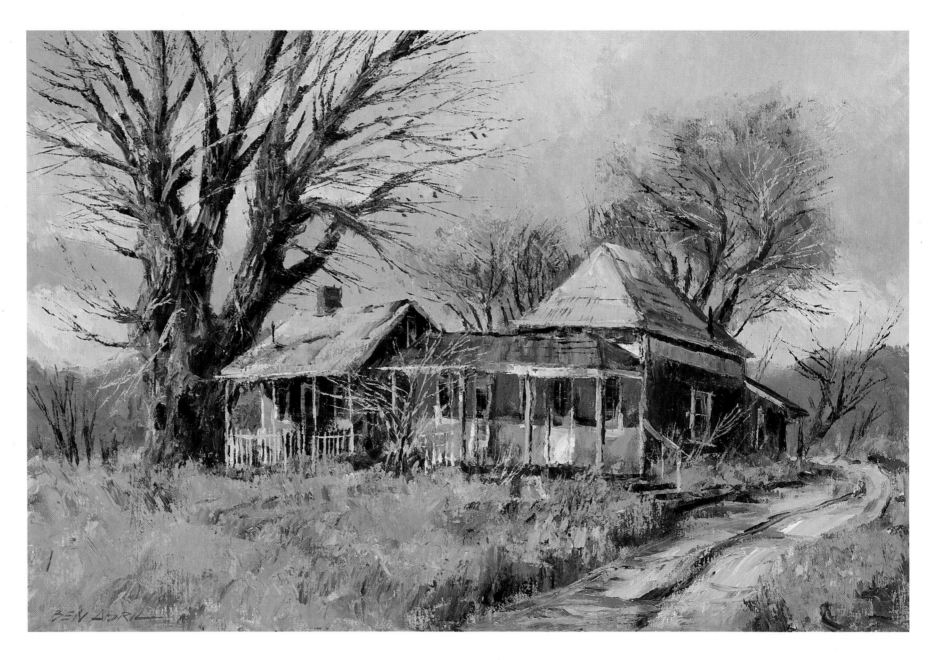

Butterfield-Overland Stage Stop

The John Butterfield Stage and Havilah Coachline used these buildings
as a rest stop along the Elizabeth Lake road from Fort Tejon to Newhall.
Although the main line to San Francisco was abandoned in 1861, at
the outbreak of the Civil War, this spur line was in continued
use until 1881. The County of Los Angeles condemned the stage stop
as being structurally unsafe in 1981 and recommended that
the buildings be demolished. A frantic plea was made to restore the
historic buildings by the Antelope Valley Chapter of the Daughters of
the American Revolution. The old buildings still remain and are
believed to be haunted. Some say that on certain nights you can hear
the muffled sounds of men shouting over the noise of wagon wheels
grinding to a halt at the stage stop.

(Oil 24" x 36")

Tropico Gold Mine

The abandoned Tropico Gold Mine in the California hills of Rosamond, north of Lancaster, was first discovered in 1896 by Ezra Hamilton. The discovery of gold came after great personal sacrifice by Hamilton whose stubborn search turned family fortunes to poverty and caused friends and family to leave him to a life of loneliness. The mine's "Glory Hole" eventually produced over three million dollars in gold. After Hamilton's death, the deed to the mine passed through many hands. In the late 1950s, Glen and Doreen Settle, part owners of the mine, moved the Palmdale School, along with a train depot and other mine shacks, to the base of the mine property, creating an authentic mining town of by-gone days. This "ghost" town has often been used in western movies and is a favorite painting site for artists. Today, the only activities at the mine are the annual Rosamond Chili Cookoff contest and occasional tours given by the caretakers.

(Oil 30" x 40")

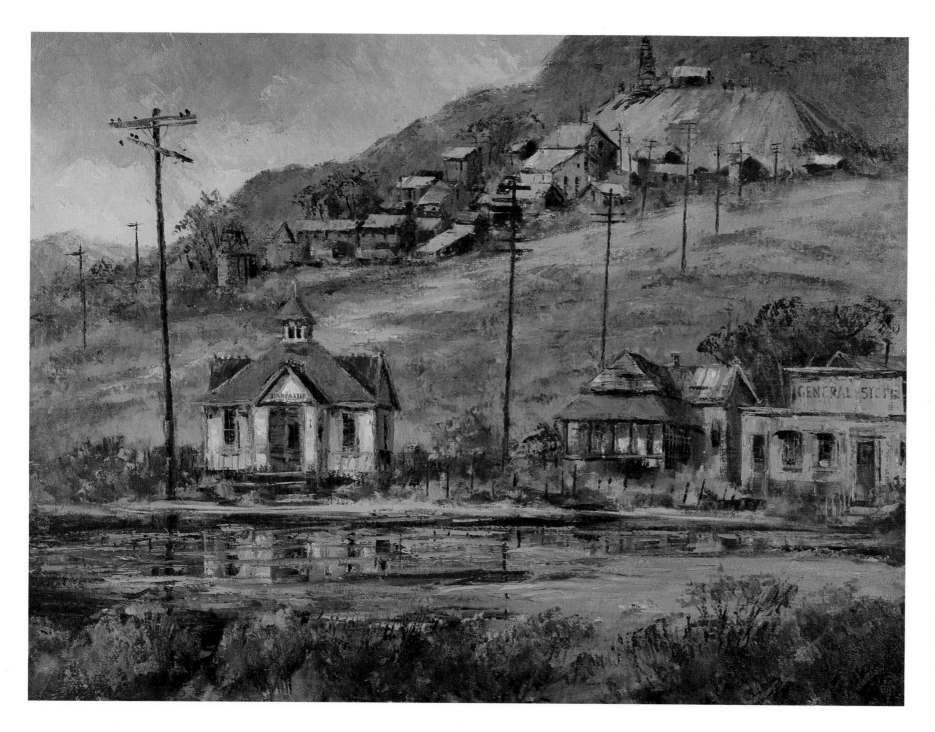

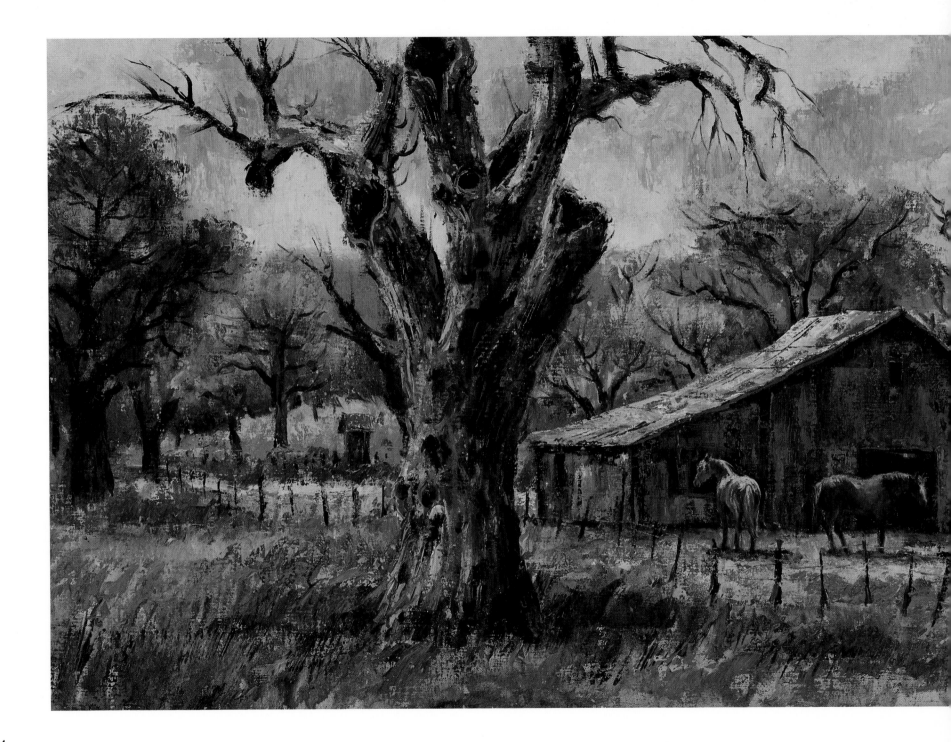

24

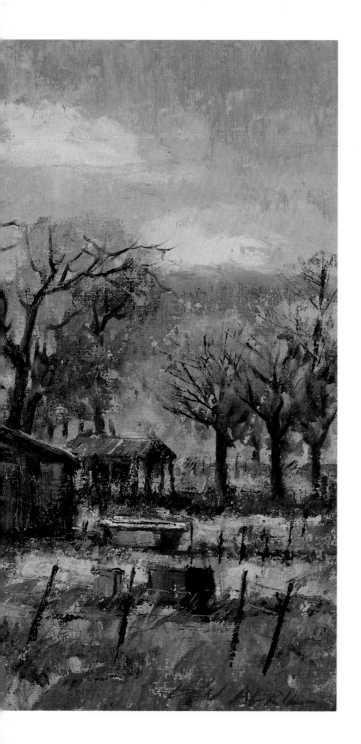

Old Owl Tree at Hart Ranch

This oak tree that is a home for hoot owls, once provided shade for the horses on the William S. Hart ranch in Newhall. Hart, first of the silent movie cowboys in Hollywood, bought the ranch in 1920 and used the property for many of his western movies. In 1925, he constructed a Spanish style castle on the hill above his 300-acre spread, furnishing it with original works of art by Remington and Russell. He entertained many celebrities here including Will Rogers, Wiley Post, Amelia Earhart and Mary Pickford. Those colorful days of yesterday have vanished, and today the Hart Ranch is a historical monument maintained by the Los Angeles County Parks Department. This painting is special to me because in the late 1930s my father did some carpentry work for Hart and I accompanied him to the ranch. Little did I realize that 50 years later I would return to do an oil painting of my boyhood remembrances.

(Oil 24″ x 46″)

The Andy Jauregui Ranch

The Andy Jauregui Ranch is located on the Placerita Canyon Road in Newhall. In 1926, Andy leased the ranch from the Standard Oil Company. He lived there with his wife, Camille, who played in several Hollywood silent movies. The small red ranch house on the property is over 100 years old. It was originally built in Pico Canyon as a dormitory for the men in the oil fields. It was moved to the ranch by mules in 1925. Andy Jauregui had been a horseman all his life. He worked for Hollywood movies as a cowboy stunt man and trick rider with cowboy friends such as Richard Dix and Bob Steele, who starred in the early westerns. In the late 1930s, Andy taught movie king Clark Gable how to do trick roping from horseback. Clark would visit the ranch on weekends with Carole Lombard. At the end of the day they would usually stay for dinner in the ranch house with Andy and Camille.

(Oil 24" x 36")

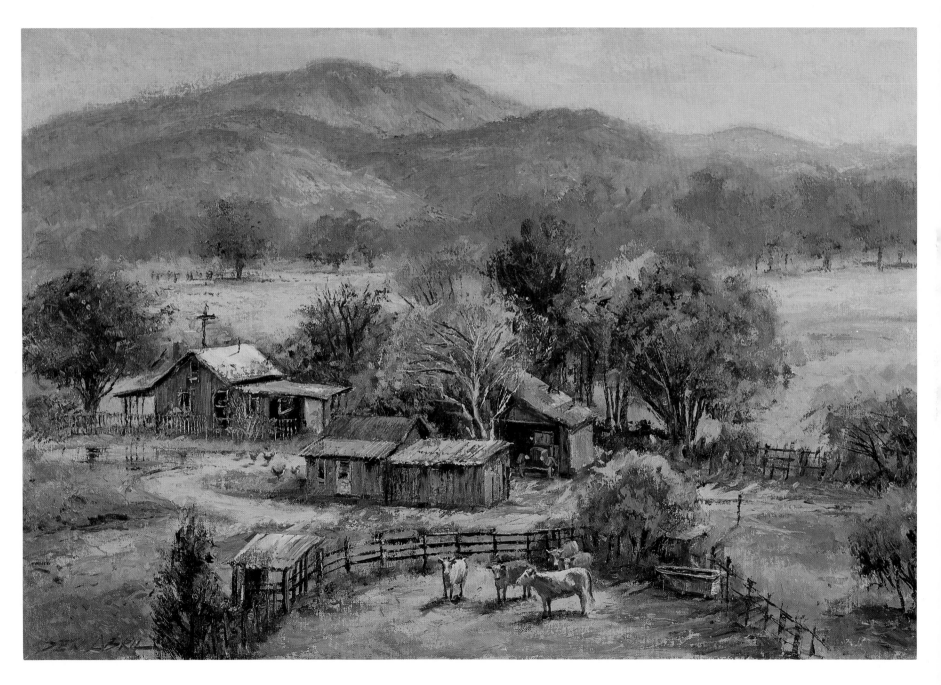

The Larinan Ranch

The York Larinan Ranch is situated along a one-way dirt road near the town of Newhall. The road was originally a wagon trail used by General Andres Pico in 1850 when he first discovered oil in California.
Larinan was primarily a bee keeper, although he did maintain a few cows for domestic use. He lived on his ranch in Pico Canyon with his wife from 1920 until his accidental death in 1975. His grandfather, who immigrated here from Ireland in 1918, purchased the original 40 acres as a homestead. He leased an additional 180 acres from the Standard Oil Company for cattle grazing. After York's death, Mrs. Larinan remained on the property with her faithful sheep dog and hired hands who tended the few remaining cows. Movie companies occasionally lease the area as a movie set. The large water tank and red barn, originally seen here as landmarks, have fallen to the wayside.
(Oil 24" x 30")

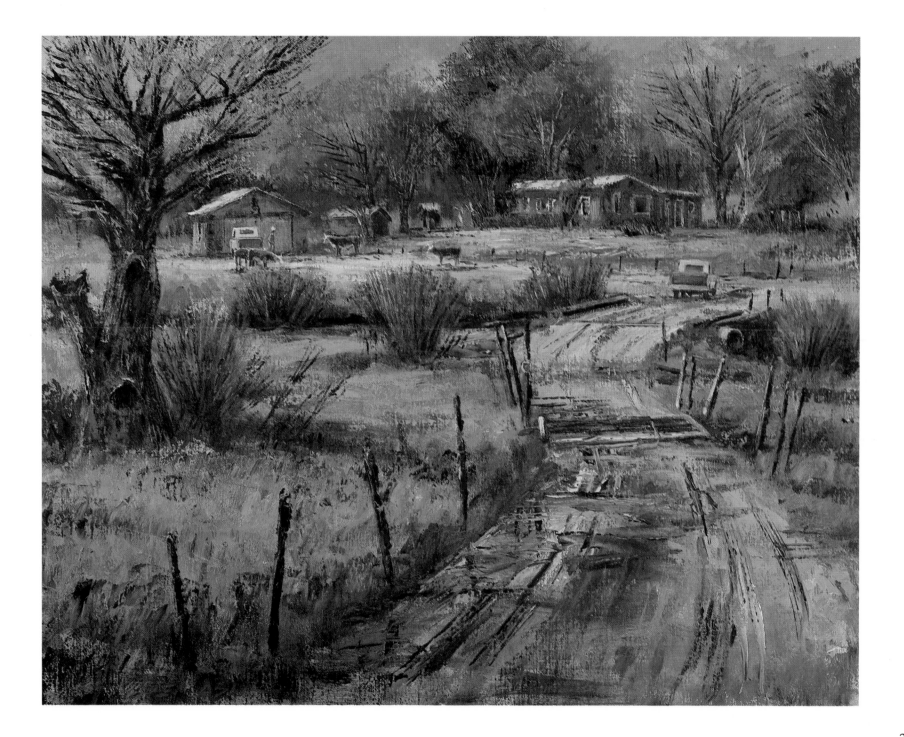

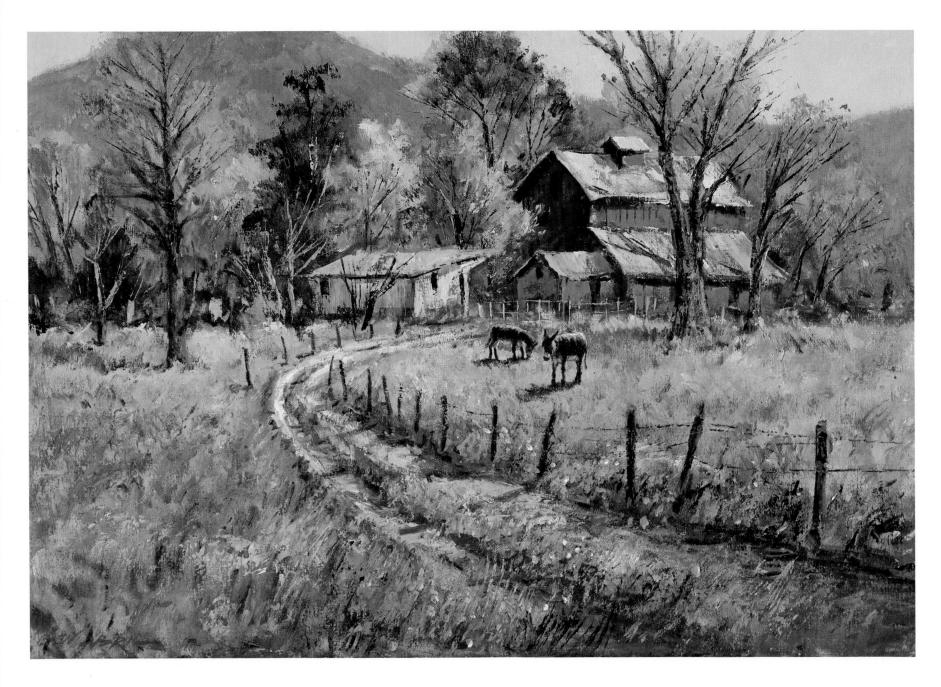

Red Barn at Acton Camp

The small town of Acton was founded by H.M. Newhall in 1876 as a railroad camp for construction workers. Newhall named the town after a community near his birthplace in Saugus, Massachusetts. In 1895, the town became a supply center for the copper, silver, and borax mines in the area. The red barn, still standing today on the outskirts of the city, was once used to store hay for the railroad mules. In the 1920s it became a setting for movies and was used as a favorite calf roping spot by the early western movie star, Tom Mix. One of his favorite tricks was to jump from the hayloft onto his white horse and gallop away into the sunset. In 1925 Tom Mix was being paid a salary of $17,000 a week by the Fox Studios. His popularity followed on the heels of silent film star William S. Hart.

(Oil 24" x 36")

End of the Line

This Southern Pacific steam locomotive, No. 1629, ran freight from Bakersfield to Los Angeles in 1936, making a regular stop at the Saugus depot. The site for the station was deeded to the Southern Pacific railway on November 30, 1867, by Henry M. Newhall. The building was opened in the late 1880s. When the locomotive was retired in 1952, the cowboy movie star Gene Autry bought it to use in movies on his Melody Ranch in Placerita Canyon. The ranch and movie town mysteriously burned down in 1962, but the locomotive was spared. Early in 1982, Gene Autry donated the locomotive to the Santa Clarita Historical Society and it was moved to the Saugus Depot. This clearly is the end of the line for old No. 1629.

(Oil 24" x 30")

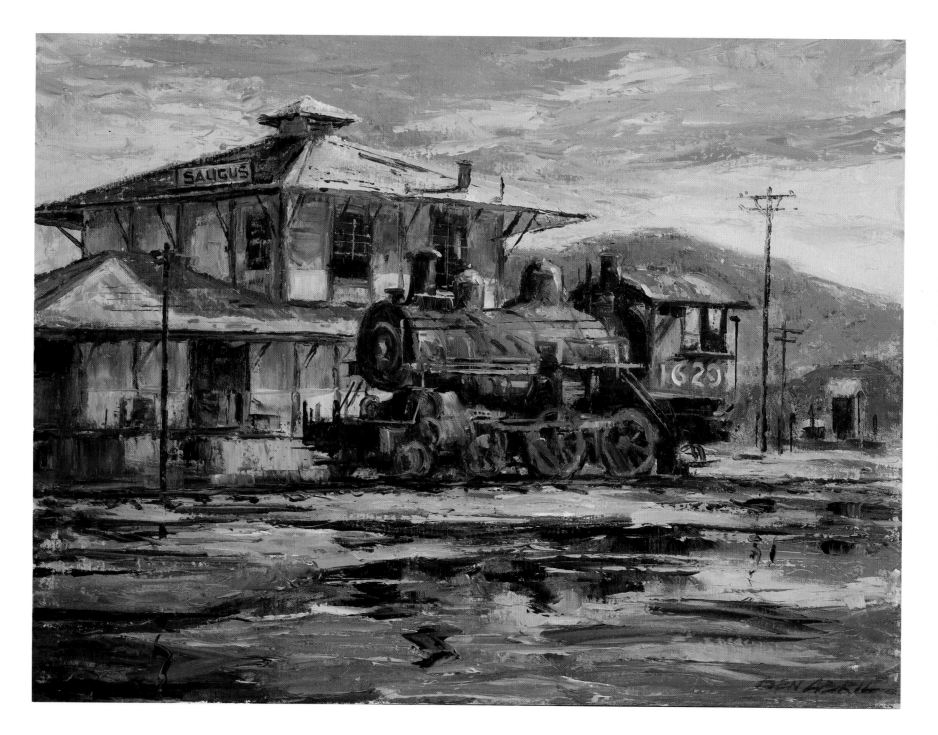

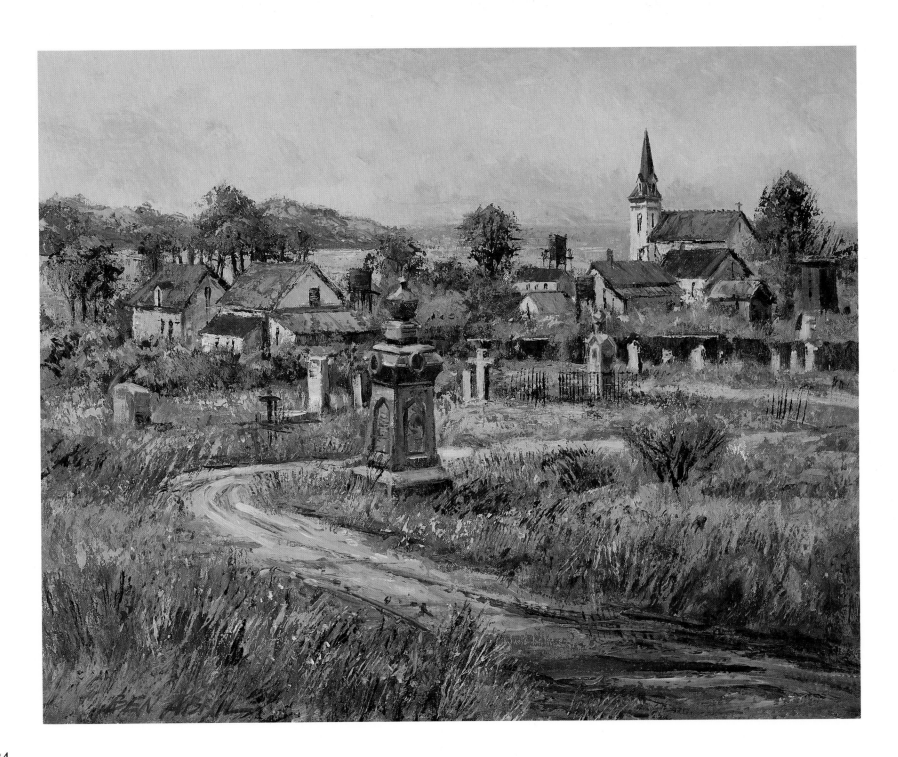

34

Mendocino Presbyterian Church

Mendocino, a picturesque seaside town 150 miles north of San Francisco, was founded in the mid 1800s as a logging camp for the gigantic redwood trees found in the area. The graveyard is located high on a hill overlooking the ocean and the town below. The tall spire of the Presbyterian church, which was built in 1868, dominates the skyline. Built of native redwood which was milled locally at a cost of $7,000, this landmark is one of the oldest Presbyterian churches in California. The movie, "Johnny Belinda," starring Jane Wyman, was filmed at the church in 1948. At the time of the filming, Wyman was married to a young actor by the name of Ronald Reagan. For her role in the intense drama, Wyman won an "Oscar" for best actress. Renting the church out as a movie set proved to be financially beneficial, and the money was used by the elders to do important restoration work.

(Oil 24" x 30")

Chinese Camp

The historic California gold town of Chinese Camp is located on the Mark Twain-Bret Harte Trail along Highway 49, an area known as California's Mother Lode Gold Country. Chinese Camp was founded about 1849 by a group of Englishmen who employed Chinese as miners. Much surface gold was found on the hills and flats. The town was headquarters for stage lines early in 1850, and also for several Chinese mining companies. The first Chinese Tong War in the state of California was fought here between Sam Yap and Yan Woo Tong. The town post office was built in 1854 and is still in use today. High on a hill, surrounded by an abandoned graveyard, a little white Catholic Church overlooks Chinese Camp. The church, named Saint Francis Xavier, was built in 1855 and its first pastor was Father Henry Aleric. An inscription on the large tombstone in front of the church reminds us of how international the population of these gold mining towns were. It reads as follows, "Sacred to the memory of Sarah Goodwin. Born February 11, 1828 — Died November 11, 1898. Native of County Tyrone Ireland. May she rest in peace."

(Oil 30" x 36")

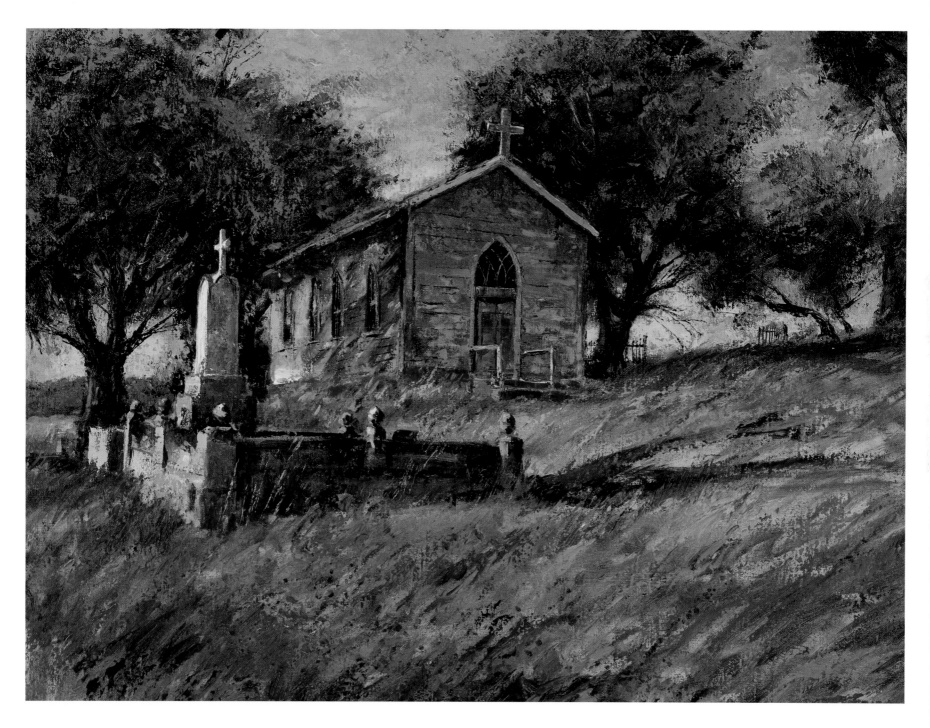

Main Street, Bodie

The abandoned gold mining town of Bodie is located 19 miles southeast of Bridgeport, via highway 395. Gold was first discovered here in 1859 by William S. Bodie. The town became the most thriving metropolis of Mono County, with a population of ten thousand in 1879. Bodie's mines produced gold valued at more than 100 million dollars. The lawless town was tough as nails and second to none for wickedness. At least one person a day was gunned down in the streets or in the saloons; "The Bad Men from Bodie" were known for miles around. Although most of the town was destroyed by fire in 1892, it still is one of the largest ghost towns in California. Some of the buildings still remaining on the main street are the red brick post office, the Odd Fellows Lodge, the Miners Union Hall and the Morgue, complete with wooden caskets inside.

(Oil 24″ x 30″)

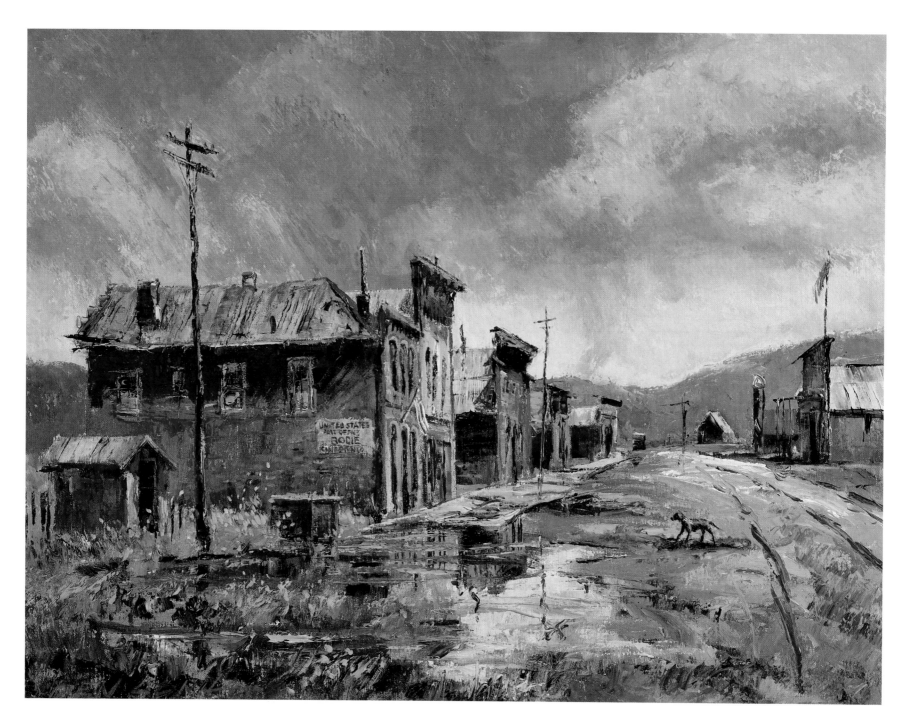

Old Nyes Crossing

The longest single-span wood covered bridge in the United States is located in the heart of the Mother Lode country near the town of Grass Valley. Once known as "Nyes Crossing," the 240 foot, 5 inch long bridge crossing the Yuba River, was built by David Isaac Wood with lumber from his mill in Sierra County. Now called "The Bridgeport Covered Bridge," it was once part of the Virginia Turnpike, a toll road which served the northern mines and the busy Nevada Comstock Lode. The road also connected Sacramento with the gold mining camps of the High Sierra. The bridge was designated a California historical landmark in 1962. Federal funds have recently been appropriated to restore the 121 year-old relic.

(Oil 18" x 36")

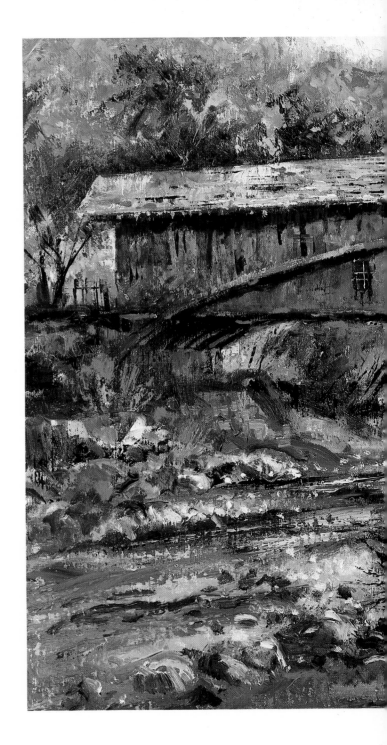

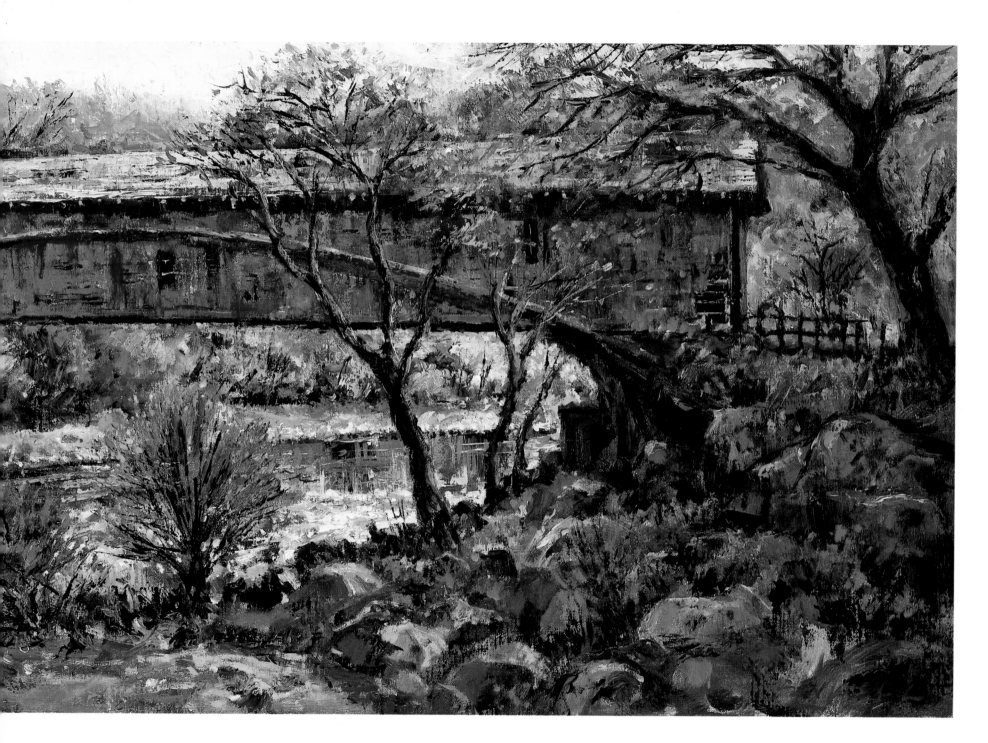

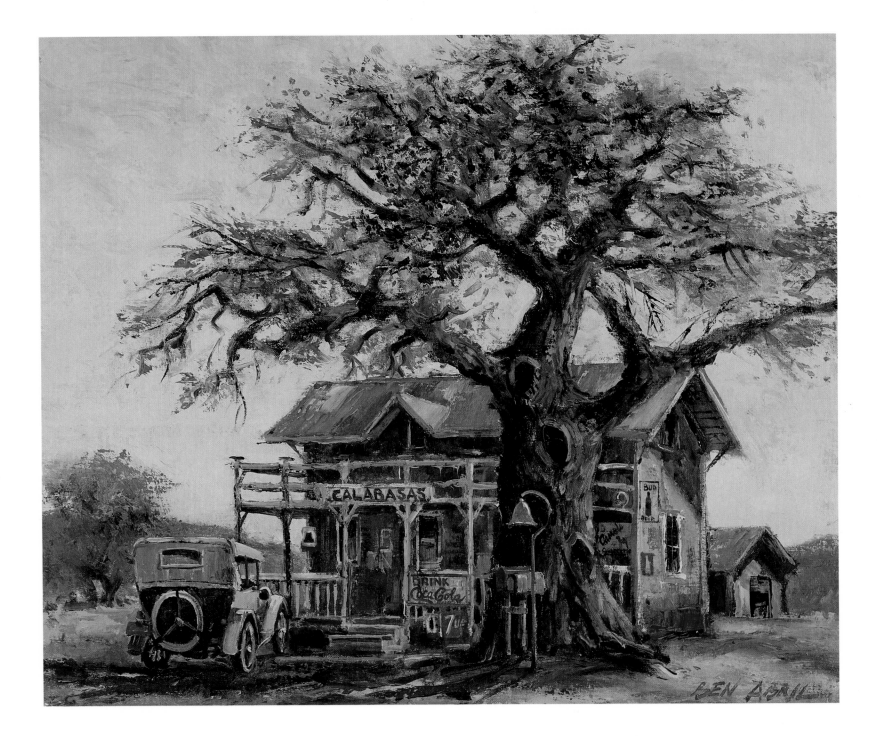

Calabasas General Store

The Calabasas General Store is located in the west San Fernando Valley across from the Leonis Adobe. The Butterfield Stage Coach Route passed through Calabasas and one of its stops was at the oak tree still standing next to the store. It is said that banditos, trying to rob the stage coach, were hung by vigilantes on the widest limb of the tree, but no official records were kept of this hearsay. Lawrence Kramer opened the Calabasas General Store in 1906, and a year later the Los Angeles Board of Supervisors placed a copper bell next to the oak to commemorate the famous Butterfield Stage Coach Route. Eventually, Kramer sold the store, and since that time the building has had several different owners. Now a restaurant, customers sedately drive into the parking lot — a far cry from the "rough and ready" days when the Butterfield Stage screeched to a stop by the old oak tree.

Oil 20" x 24")

Old Woodfall Road

Old Woodfall Road, originally a path for early day fur trappers entering the Angeles National Forest, begins at the junction of Lost Canyon and Highway 14 in Saugus. The mile-long road crosses a small stream ending at the Agajanian Brothers' Pig Farm. The Agajanian brothers began their pig farm in the 1930s and during World War II they had a government contract to supply the troops with ham and bacon. After the war the Agajanians' abandoned their venture and went into professional car racing. Today, only a few prize hogs which are used in county fair exhibitions remain on the farm. Old Woodfall Road is seldom traveled except for a lone pick-up truck or maybe an artist looking for that perfect scene on the other side of the hill.

(Oil 24" x 30")

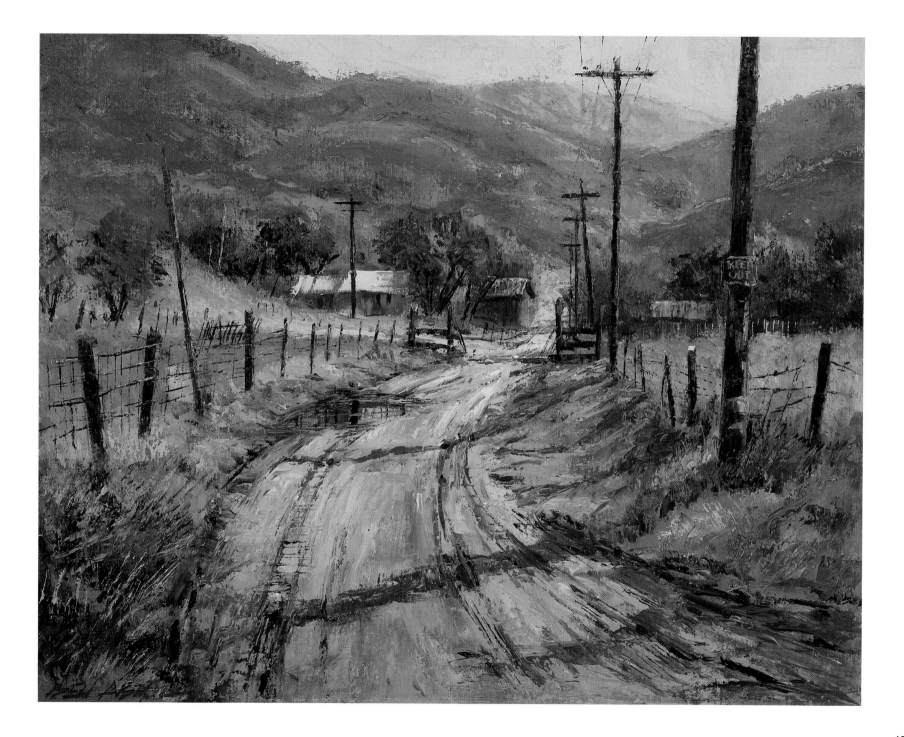

Mission San Luis Rey de Francia

The San Luis Rey Mission was founded in 1798 by Father Fermin Lasuen, following Father Serra's death. It was the 18th mission to be built along the California coastline. Located near Oceanside, this mission site was a long day's ride by horseback from the San Diego mission. San Luis Rey de Francia was the largest and most populous mission, boasting 3,000 working indians and over 60,000 head of domestic animals along with many bountiful fruit orchards, vineyards, olive trees and wheat fields. After independence from Spain, the Mexican government took over management of all the missions. Over the years, San Luis Rey eventually fell to decay and ruin. In 1865, President Abraham Lincoln returned the mission to church ownership. Today, Mission San Luis Rey De Francia has been restored to its former beauty and proudly wears the crown as "King of the Missions."

(Oil 30" x 40")

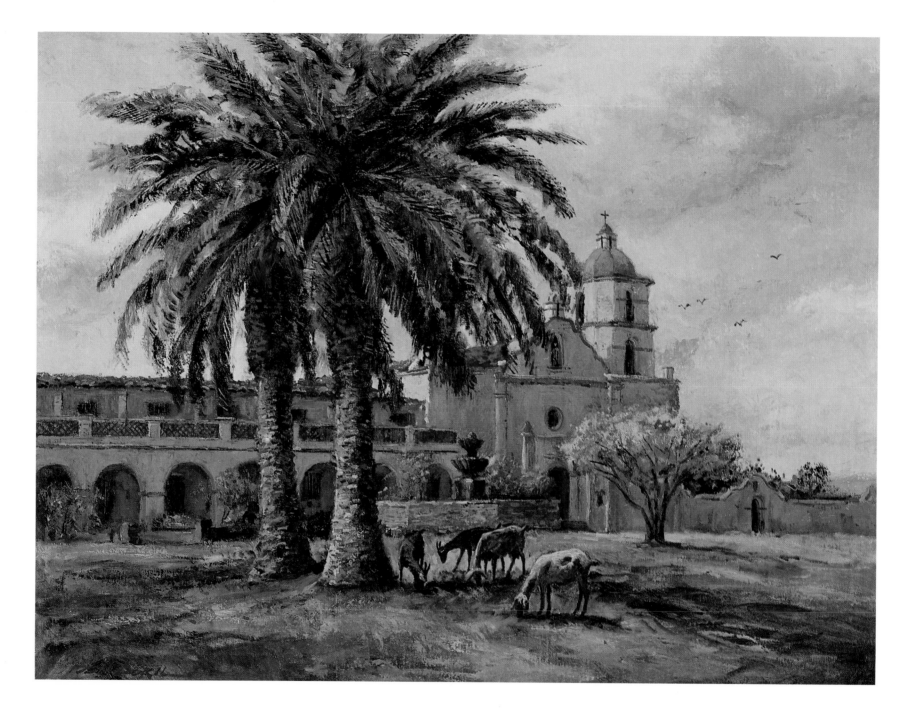

Leonis Adobe

Just 20 miles northwest of Los Angeles, in the town of Calabasas, stands the Leonis Adobe residence. It was built of sun-dried adobe bricks on San Fernando Mission land in 1844. In 1850 the ranch and adobe house were acquired by Miguel Leonis, who was known as the "King of Calabasas." He was a legendary and colorful figure of the old San Fernando Valley days. An armed retinue of Mexicans and Indians guarded his vast holdings of property and cattle. Miguel married an Indian widow, Espiritu Chujilla, and they lived in the adobe residence until his accidental death in 1889. Espiritu lived in the house until her death in 1906. Her grave marker may be found at the San Fernando Mission Cemetery. Successive residents of this colorful adobe house claim that they have heard the ghost of Leonis bumping about the rooms, reportedly looking for his misplaced cache of money.

(Oil 24" x 30")

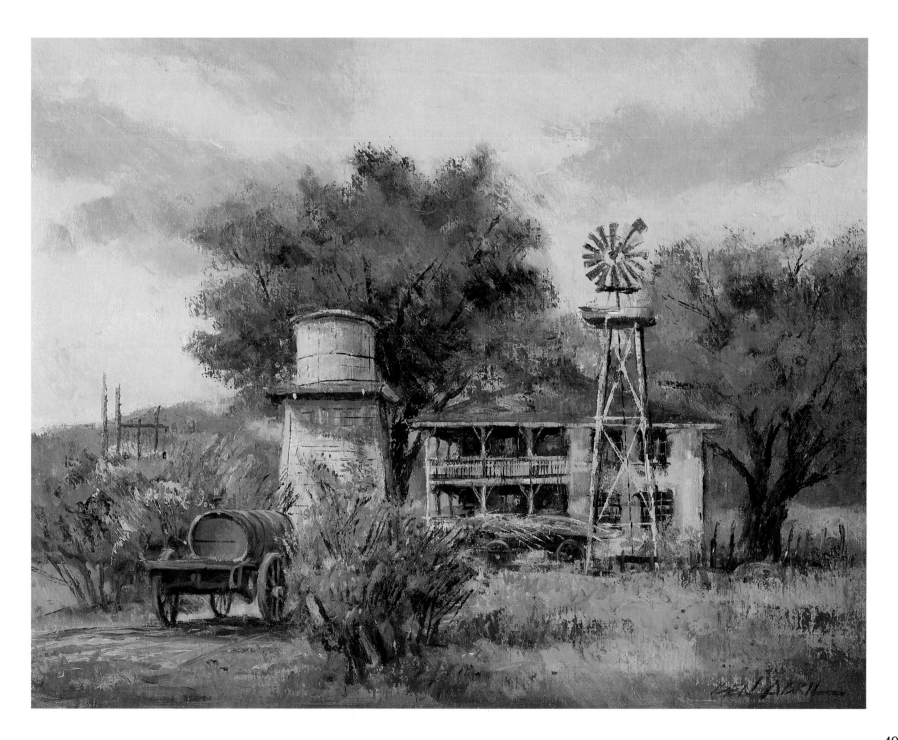

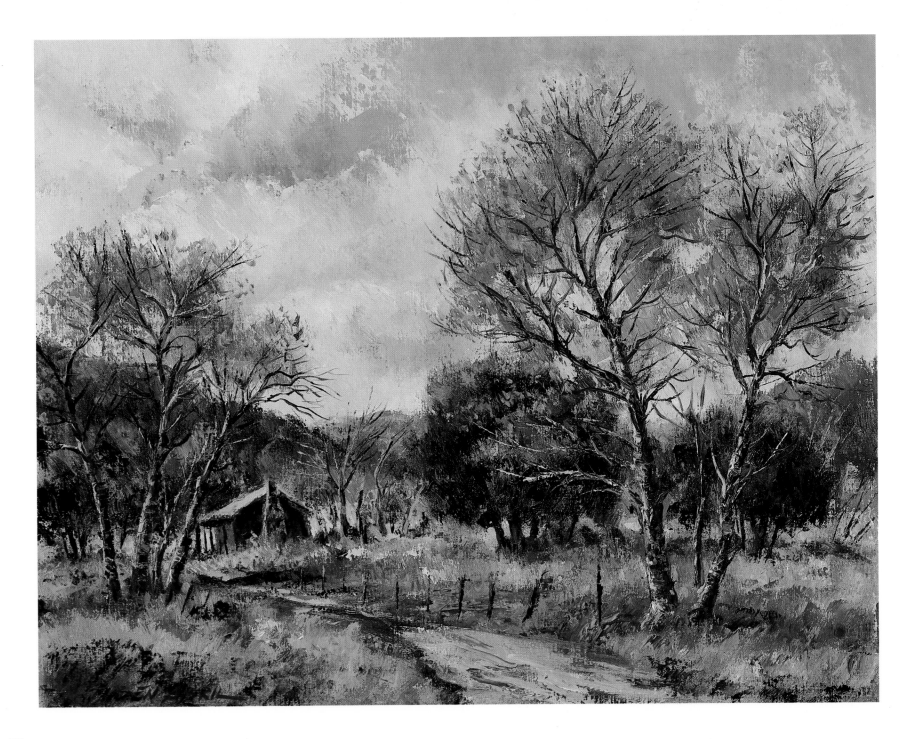

The Walker Cabin

The small Walker cabin is located on the banks of the Placerita Canyon stream in Newhall. It was the homestead of Frank Evans Walker, an early settler of the Santa Clarita Valley. Walker never struck it rich, but made an adequate living panning gold in the nearby stream. True pioneers, he and his wife, Hortense, built the cabin in 1920 with simple hand tools. With their family of twelve children, they soon outgrew the tiny one-room cabin and in 1938 the Walker family moved to Palmdale. From 1940 to 1948, the cabin and surrounding areas were used as movie settings for many of the "Hopalong Cassidy" films produced by Paramount Studios.

(Oil 24" x 30")

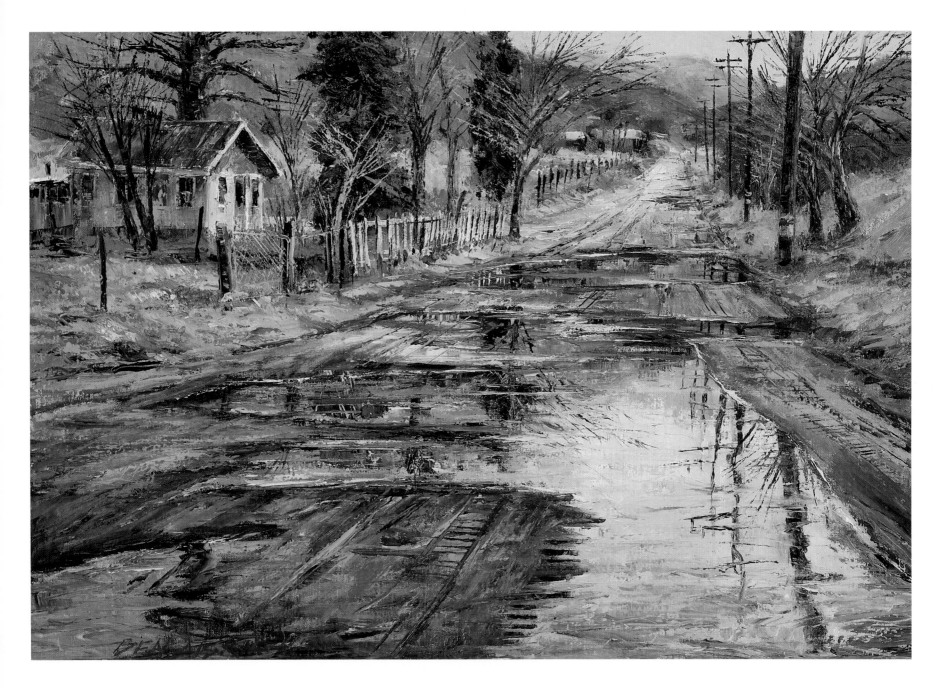

After the Rains

One of my favorite locations to paint, especially after the rains, is this lonely dirt road in the Sulphur Springs area of the Santa Clarita Valley. The road is usually deserted and in the winter months it is full of reflective water puddles. The yellow house along the road was built by Col. Thomas Finlay Mitchell as a bunk house for the hired help who worked his 1300-acre ranch. The first house on the property was an adobe residence built in 1860, and it still stands today behind the yellow bunk house. While painting on this road, I can hear the lonesome whistle of the Southern Pacific freight trains as they wind their way across the valley on the Los Angeles to Mojave run.

(Oil 24" x 36")

The Old Palmdale School

This schoolhouse, once located in Palmdale, now stands in a ghost town at the foot of the Tropico Gold Mine. The first school in Palmdale, the building was constructed of redwood lumber and square nails in 1888. After about two decades of use, the school was sold and moved to the neighboring town of Lancaster. As Lancaster grew it was necessary to replace the old school with a larger, more modern one. The building went on the auction block and was bought and turned into a rooming house. In 1950, Glen and Doreen Settle, part owners of the Tropico Gold Mine, bought and restored the building to its original form. Now retired, the Settles have deeded ownership of the old schoolhouse back to the city of Palmdale.

(Oil 18" x 24")

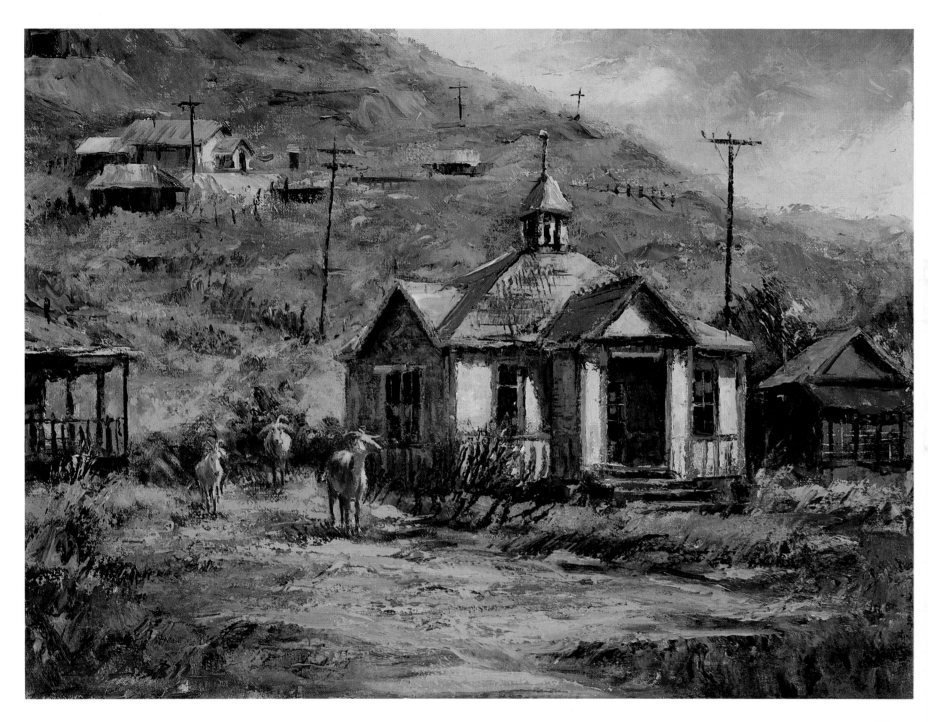

In Whitney Canyon

These abandoned bunk houses and horse barns are all that remain of a
thriving 640-acre ranch in Whitney Canyon on the outskirts of Newhall.
The land is owned by Phillips Petroleum Company who maintained 28 oil
wells on the property. Jose Jaramillo, a young ranch foreman, and
twelve hired hands managed the ranch from 1946 to 1959. About 150
head of white-faced Herefords and 50 quarter horses were run on the
property. In 1960 the cattle ranch was turned into horse riding
stables. Movie studios used the property in 1966 to film a western
movie series called, "The Roughneck," featuring the legendary lawman,
Bat Masterson. The Whitney Canyon Ranch was eventually disbanded.

(Oil 24" x 30")

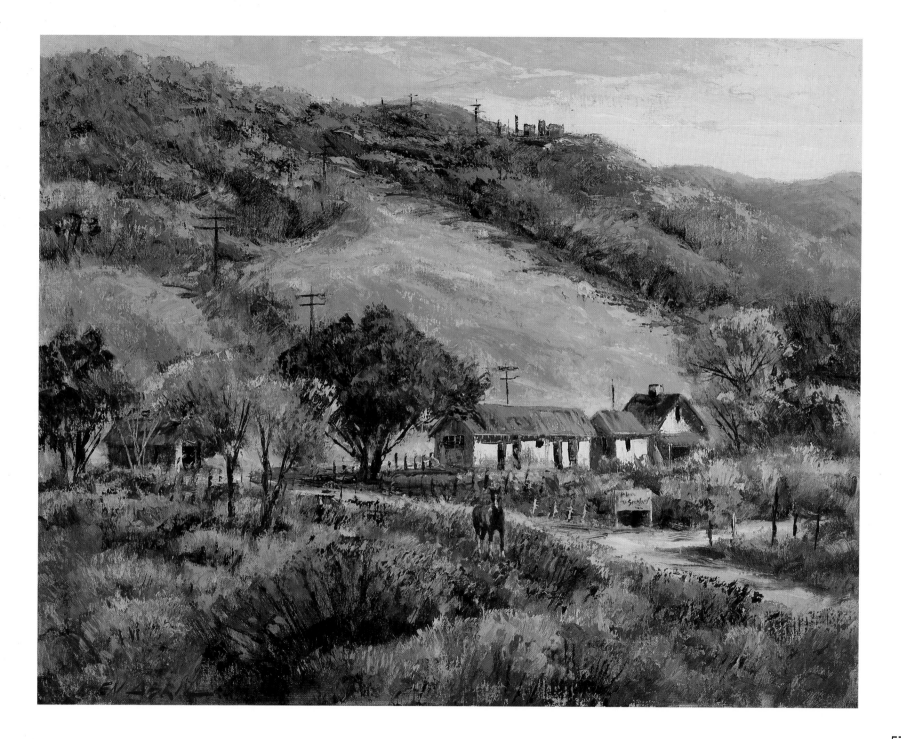

Lincoln Park Boathouse

In 1874, the city of Los Angeles purchased a lake and several acres of land at the north end of Main Street from John S. Griffen. It was developed into a park and zoo called Eastlake Park. In 1896 the Pacific Electric Rail Company extended its rails to the end of Main Street and the park. Red electric streetcars brought picnic and pleasure seeking families to this oasis in the city. The park was renamed "Lincoln Park" and by the early 1900s it was one of the most popular gathering places in the city. A carousel and boathouse were added and electric motorboats glided silently over the lake's surface. Today, over 100 years after it was built, the lonely sight of the abandoned red brick boathouse conjures images of a more leisurely and gentle way of life.

(Oil 24" x 30")

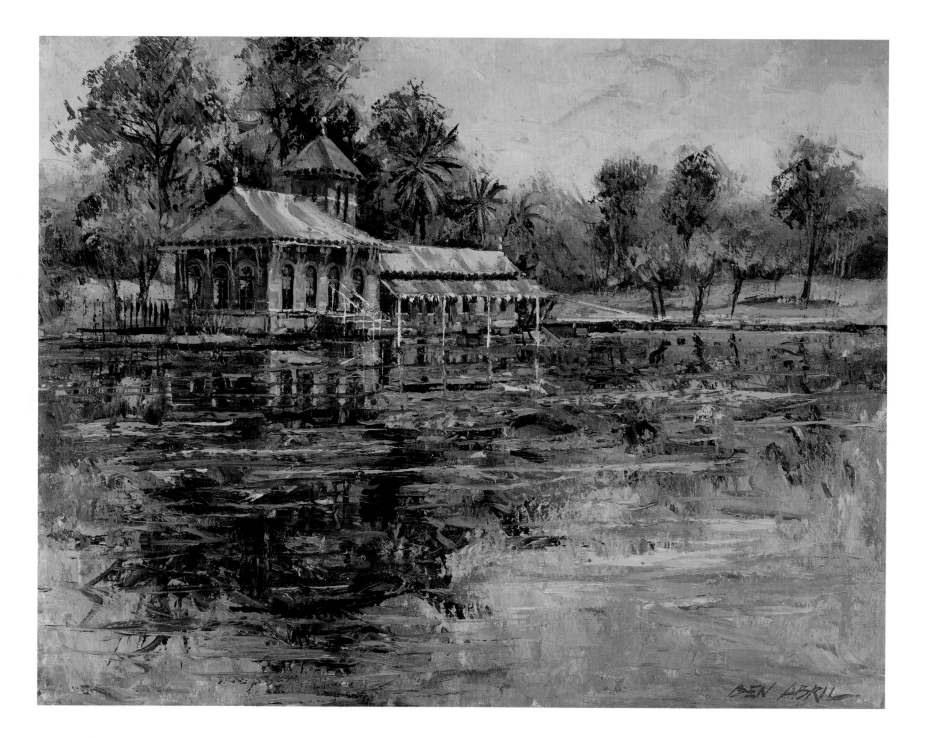

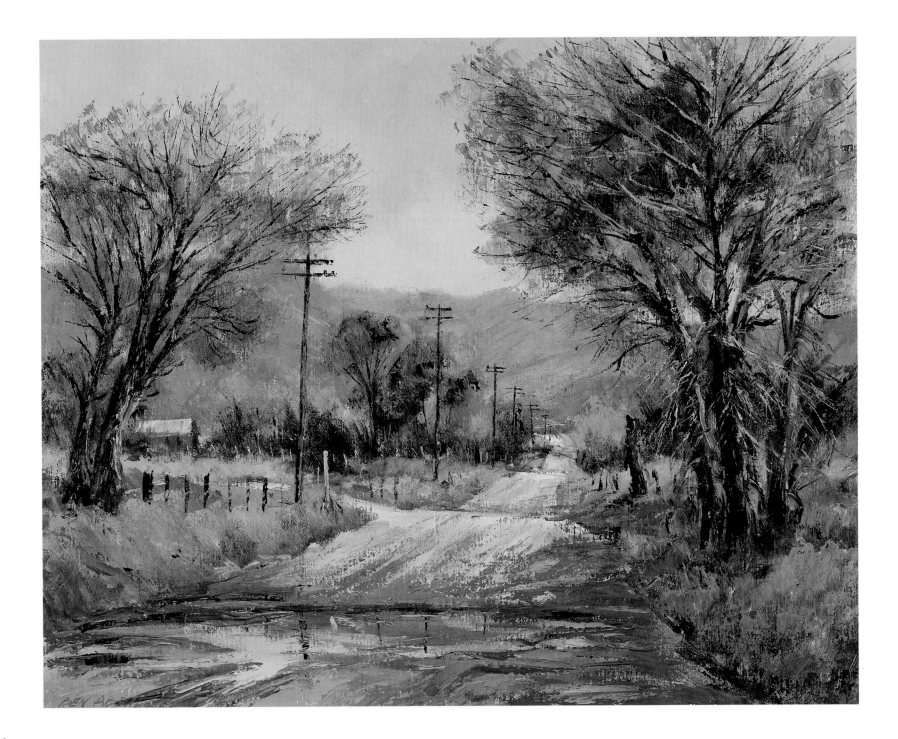

Road to the Lilac Ranch

This dirt road, in the hills of Acton, leads to the Colombo Lilac
Ranch. In the late 1800s the road was a footpath that eventually
led to the discovery of copper and borax mines in the nearby hills.
Later the road was widened into a wagon trail to haul the ore out for
processing. Eventually the mines ceased producing and the road was
practically untraveled. In 1935, Chris Colombo Brezidoro bought 50
acres of land at the end of the road. He rebuilt the road, which
crosses a small stream, and established his home and a lilac ranch.
Hearsay claims that in 1900, President Theodore "Teddy" Roosevelt used
the nearby town of Acton as a hunting retreat.

(Oil 24" x 30")

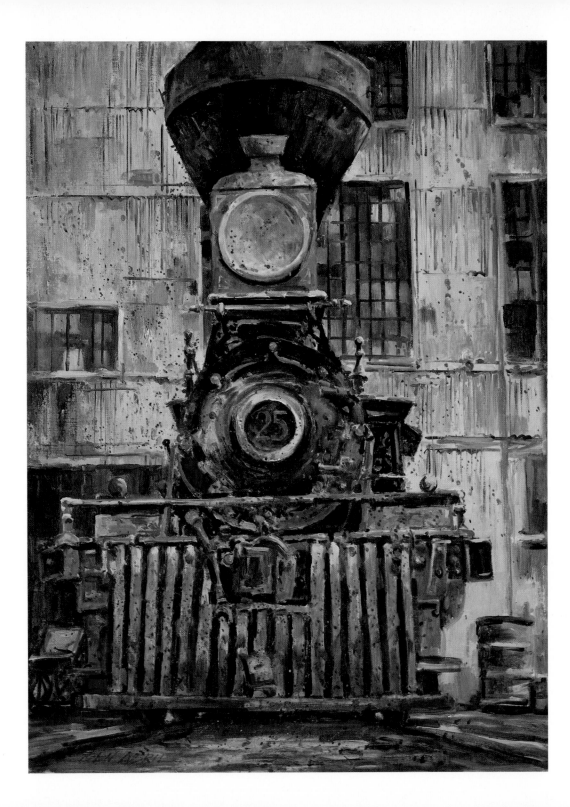

62

Baldwin Ten Wheeler

This 45-ton steam giant was built in 1905 by the Baldwin Locomotive
Works for the Virginia and Truckee Railroad. She saw 40 years of
public service. In 1945 the cap-stacked Baldwin was fitted with a
false diamond stack and an oversized headlight for a special Nevada
Admission Day train. In 1947 the locomotive was sold to RKO
Pictures. She eventually appeared before the cameras in 10 films.
In January 1955 she was featured on a special 50th anniversary
excursion by the Railway and Locomotive Historical Society between Los
Angeles and San Pedro. Lettered as San Pedro Los Angeles and Salt Lake,
Union Pacific number 25, this was her last public steaming. She was stored for
many years in the Union Pacific's East Los Angeles yard before her
final resting place in the historical collection at the Nevada State
Museum, in Carson City.

(Oil 40" x 30")

Queen Anne Cottage

The Queen Anne Cottage was built by E.J. "Lucky" Baldwin in 1879 on an 80,000-acre parcel of land originally known as Rancho Santa Anita. Striking it rich in Nevada's silver mines, Baldwin built the charming cottage as a honeymoon gift to his fourth wife, 16 year-old Lillie Bennett. Situated next to a natural lake, no expense was spared in the construction or interior furnishings. "Lucky" Baldwin died in 1909 and the estate passed on to his family. In 1936, the Queen Anne Cottage and 1300 acres of land, was sold to Harry Chandler, publisher of the Los Angeles Times Newspaper. In 1947, the State of California and the County of Los Angeles, jointly purchased 111 acres of the Rancho for use as the Los Angeles County Arboretum. The Rancho and the Queen Anne Cottage are a popular filming spot. Movies such as "Tarzan, the Ape Man," starring Johnny Weismuller with Maureen O'Sullivan and "The African Queen," starring Humphrey Bogart with Katherine Hepburn, are particularly notable. More recently, the television series "Fantasy Island," starring Ricardo Montalban and Herve Villechaize, was filmed at the site.

(Oil 30" x 40")

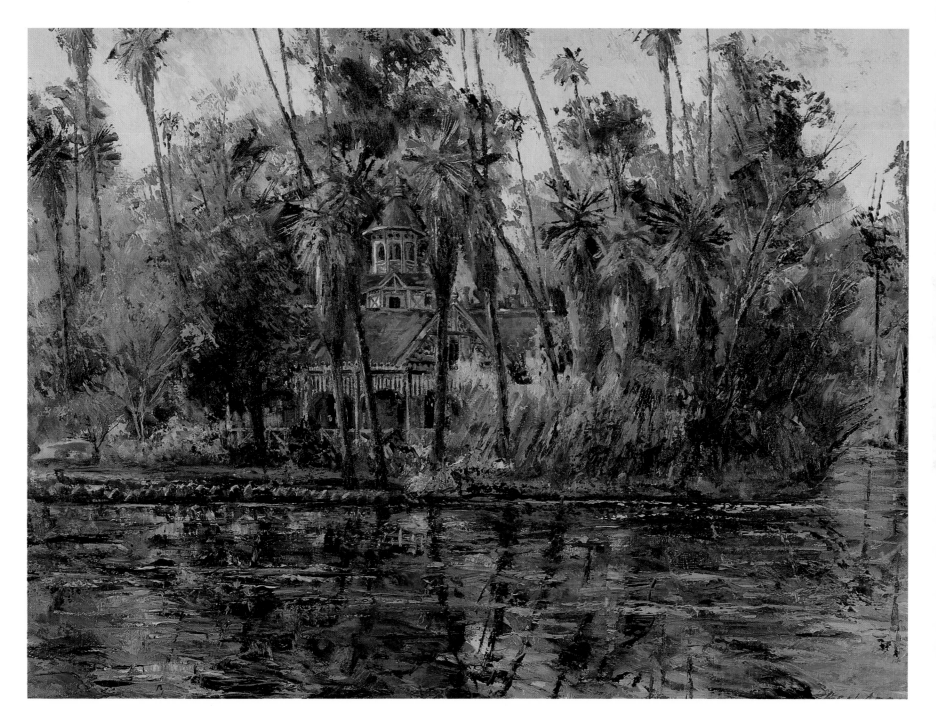

Home of Ramona

This red brick winery and the house behind it are located in Piru.
The buildings are on the Camulos Ranch which is known as the home of
"Ramona." Helen Hunt Jackson, lived on the ranch while she wrote
the famous story. The ranch dates back to January 22, 1839, when
Governor Juan Alvarado granted the Rancho San Francisco, with 45,815
acres of land, to Antonio del Valle. The del Valle family chose
Camulos as their home and planted large orchards of citrus and walnut
trees on the property. Several movies have been filmed on the ranch
including the original "Ramona" starring Loretta Young and Don
Ameche. Later it was the site for the filming of a scene in the
"Francis Gary Powers Story." In the film, the Camulos winery was
transformed into the Russian winery where Powers was captured.
(Oil 24" x 30")

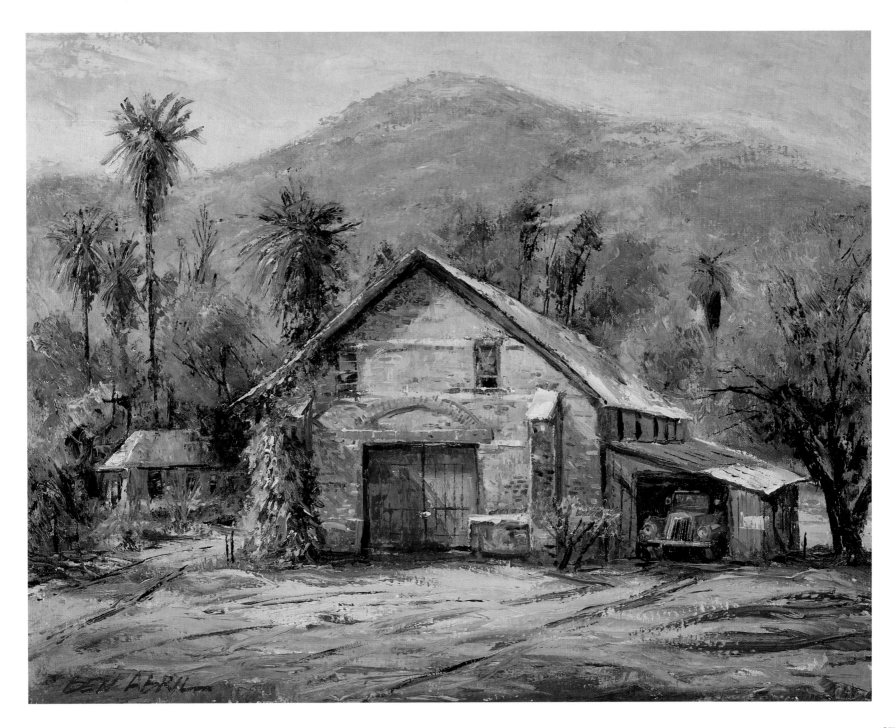

Oak of the Golden Dream

On March 9, 1842, six years before the great California gold rush at
Sutter's Mill, gold was first discovered along this stream in
Placerita Canyon near the present town of Newhall. The discovery was
made by Francisco Lopez during a pause for an afternoon meal while
rounding up lost cattle. Legend says that as he was resting against
an oak tree on the banks of the Placerita stream, he pulled up wild onions
to season his food and was surprised to find flecks of gold clinging
to the roots. When the news of his discovery leaked out, hundreds of
prospectors rushed to the area to file claims. In the first year,
$10,000 worth of gold was shipped from Newhall to the United States
mint in Philadelphia. The famous oak tree, now known as, "The Oak of
the Golden Dream," still stands today next to the bubbling stream.

(Oil 24" x 36")

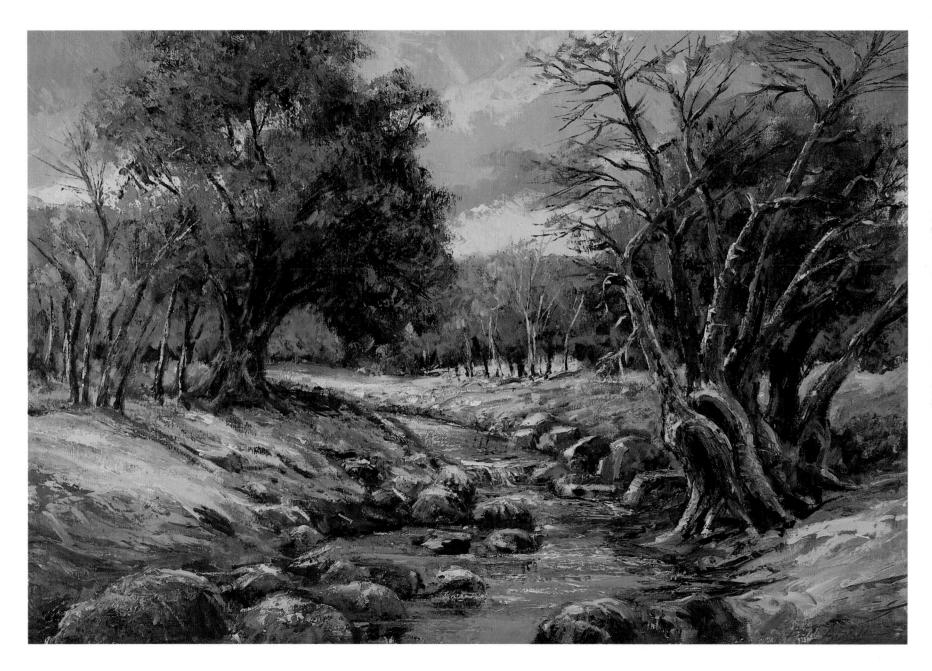

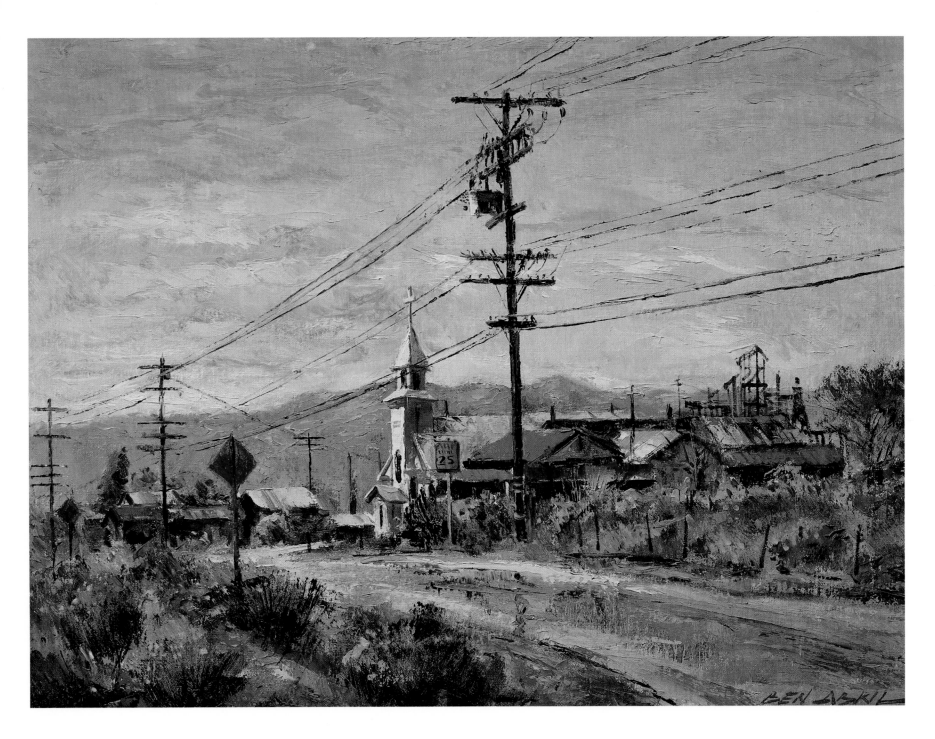

70

Coming Into Town

Located in the California desert, 20 miles south of the China Lake
Naval Weapons Center, is the abandoned ghost town of Randsburg. Its
name and the neighboring town of Johannesburg, were adopted from the
Rand mining district of South Africa. The main street of the town
leads to the Yellow Aster Mine. Randsburg was quickly formed in 1895
after the discovery of gold by three miners, Singleton, Burcham and
Mooers. After two years of working their claim with little luck, they
were ready to give up. Down to their last pound of bacon rind and
coffee they made one last search for gold. Slicing into a prominent
rock, Mooers struck "pay dirt." The site became the "Glory Hole"
of the Yellow Aster Mine, producing over two hundred million dollars
before it closed. Today, Randsburg is nearly a ghost town with a
dwindling population of about 85 retirees, including some of the
old-time prospectors. The wild exuberance of this former boom town
has disappeared, but the skeleton of the Yellow Aster Mine still
dominates the desert landscape.

(Oil 18″ x 24″)

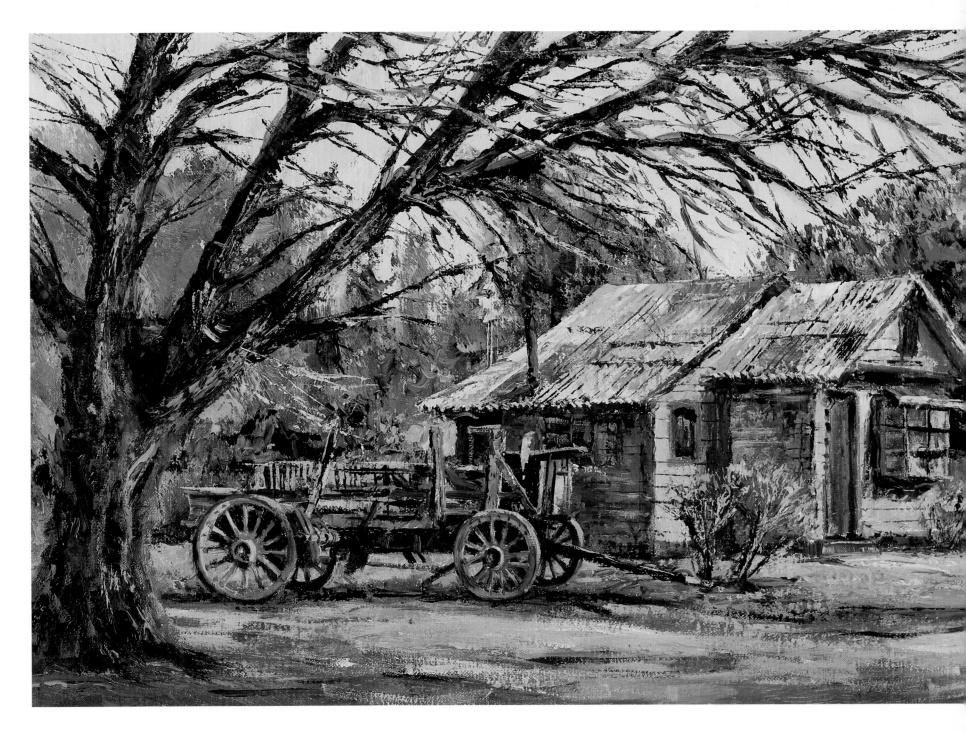

Old Miner's Cabin

Fading in the hot California sun is this gold-painted clapboard miner's cabin, part of the Melody Ranch. In 1930, Ernest Hickson of Monogram Pictures, began building a western town to be used as a permanent movie set in Placerita Canyon. He moved several authentic buildings to the property from Newhall and Saugus. The newly constructed main street was called "Slippery Gulch." Some of the great western cowboy stars performing at the newly created "old" town were William Boyd, who played "Hopalong Cassidy"; Clayton Moore, who played "The Lone Ranger"; Roy Rogers; and Gene Autry. The famous movie Indian chief, Iron Eyes Cody, also starred in movies shot at the ranch. When Hickson died in 1952, the town was sold to Gene Autry who named it "Melody Ranch." Western movies continued to be filmed there until the town was destroyed in 1962 by fire. Still remaining on the property is an antique locomotive, a train station, a schoolhouse, and the miner's cabin.

(Oil 16" x 30")

Santa Anita Depot

In 1886 the Los Angeles and San Gabriel Railroad ran track through the Rancho Santa Anita, from the Los Angeles station to Mud Springs, later known as San Dimas. "Lucky" Baldwin, owner of the Rancho Santa Anita, granted the railroad a right-of-way through his property in an agreement for a depot to be built on Baldwin Avenue in the center of his ranch. He also agreed to pay $10,000 in U.S. gold coin for the Santa Anita depot. In 1890, after plans were drawn up for the red brick depot, the Los Angeles and San Gabriel Railway had merged into the Atchison, Topeka and Santa Fe Railway. The depot was completed in 1891 and was used mostly by "Lucky" and his guests while visiting the ranch. In 1904, President Theodore "Teddy" Roosevelt and his "Rough Riders" made a whistle stop at the depot during his re-election campaign. After Baldwin's death in 1909, the depot was used by the railroad only for special stops. Today, the depot stands two miles south of its original location and is a historical monument.

(Oil 24" x 30")

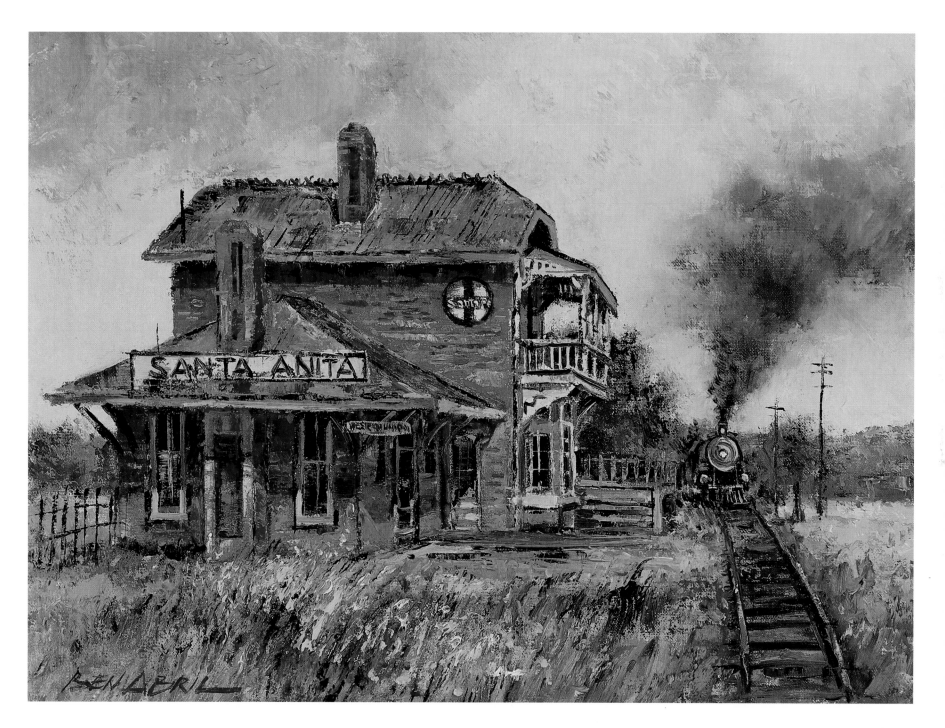

Lake Elizabeth Stage Road

This sycamore tree-lined road along Lake Elizabeth, was first discovered in 1776 by Francisco Garces, a Fanciscan Friar and explorer. Situated in the Sawtooth mountain range, the road eventually became a stage coach mail route from Newhall and Saugus through Gorman and north to Fort Tejon. The main Butterfield Overland Stage Route was founded in 1858 and ran twice a week from St. Louis and Memphis to Los Angeles and San Francisco. The stage coach made the 2,800 mile journey in 25 days. Between 1873 and 1874, the Lake Elizabeth road was frequented by the infamous California bandit chief, Tiburcio Vasquez, while traveling to his hideout in Little Rock Creek. After many years of horse stealing and stagecoach robbing, the state legislature appropriated a $15,000 reward to capture him. One of the last of the early California desperados, Vasquez was captured by a sheriff's posse in 1874 and died by hanging on March 18, 1875.

(Oil 24″ x 30″)

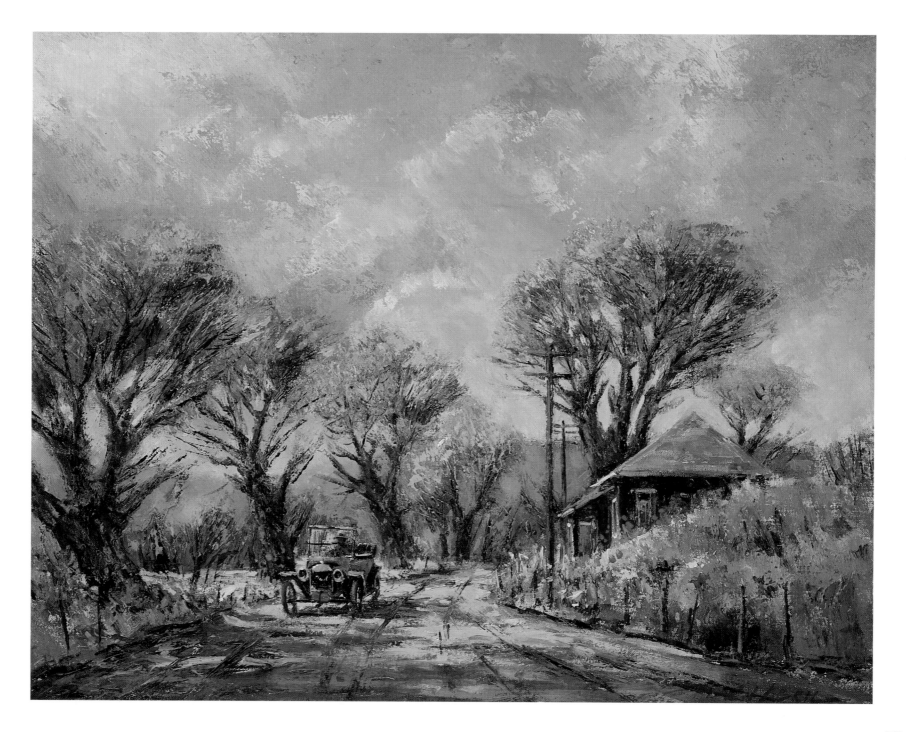

Fort Tejon Military Post

The Fort Tejon Military Post is located 77 miles north of Los Angeles on the "grapevine" pass of the Tehachapi mountains. The post was established by the United States Army on June 24, 1854, to suppress cattle rustling and to protect the Indians in the San Joaquin Valley. Fort Tejon was the regimental headquarters for the First U.S. Dragoons. Fifteen officers who served here achieved the rank of General in the Civil War. Eight officers served with the North and seven with the South. In 1858, under the direction of the U.S. Secretary of War, camels were imported to the Fort for transporting supplies to isolated posts as far away as Fort Defiance, New Mexico. In 1864, after serving its usefulness, Fort Tejon was disbanded. Seventy five years later, the State of California purchased the fort and 200 acres of surrounding land to be used as a state park. In 1973 Walt Disney Productions used Fort Tejon as a site for the movie "One Little Indian," starring James Garner.

(Oil 24" x 30")

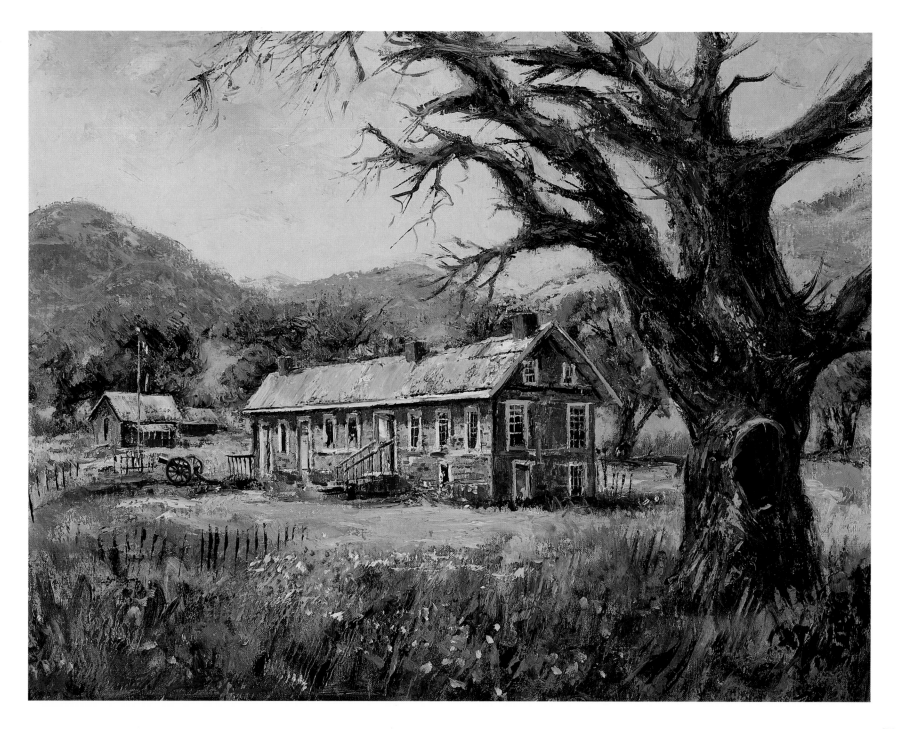

The King Ranch

This California ranch is located on a seldom traveled dirt road
leading to Lake Piru in the Topatopa mountains. The 5,000-acre ranch
was once owned by the estate of the late multi-millionaire, J. Paul
Getty, but is now under the ownership of Texaco Oil Company. The ranch,
which had 27 producing oil wells, has been leased for many years by
Morris King and his son Robert, who have 300 head of beef cattle and
some sheep on the property. The red ranch home, built in 1890, is
surrounded by a grove of eucalyptus trees in the center of the property.
With the large flat fields on the ranch, it has been a popular movie site
when the landing of antique airplanes was required. The Disney film
"The Great Waldo Pepper," starring Robert Redford was filmed here, as
well as the movie, "Amelia Earhart."

(Oil 30" x 40")

Detail of the King Ranch

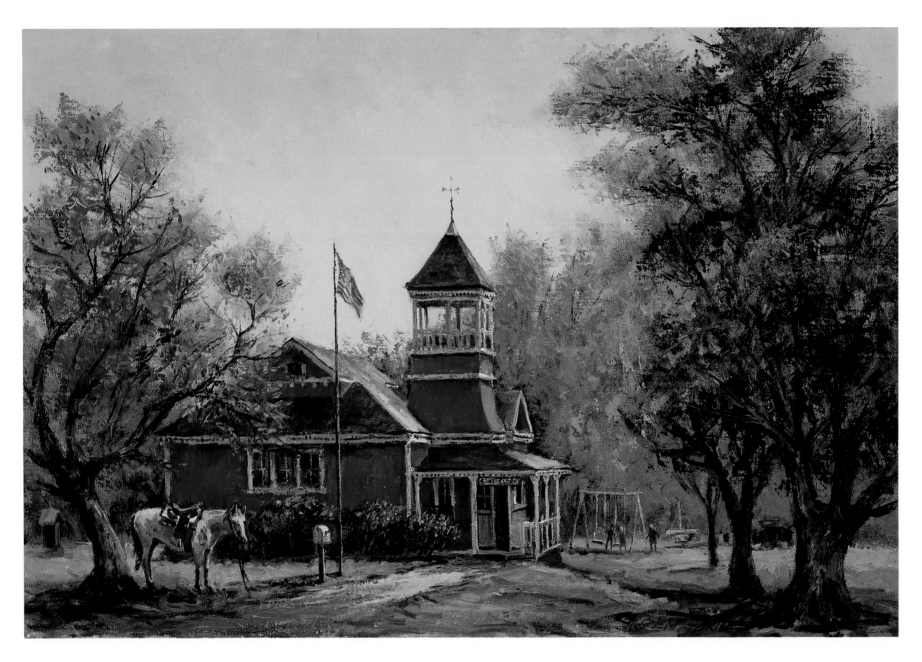

82

Santa Clara Elementary School

This quaint one-room schoolhouse, with 31 students attending grades 1 through 6, is still in use today. It is located on Telegraph Road, near the banks of the Santa Clara River, in the town of Santa Paula. Built in 1896 at a cost of $2,634.35, this red building replaced a grey colored school that burned in 1895. Miss Steepleton, who was the teacher at the time, helped fight the blaze. Tragically, her long skirts caught fire, engulfing her in flames. Although she was rushed to the hospital, she died 12 days later. There was a colorful succession of teachers in the new red school house. These pioneering teachers were a hearty bunch, and more often than not, their primary mode of transportation to the schoolhouse was by horseback. Today, as in the beginning, the clanging bell in the tower calls students to class. The students take turns being the bell ringer.

(Oil 20" x 30")

Morrison Ranch House

The Morrison Ranch House was built in 1898, along the Butterfield
Stage Coach Route on Las Virgines Canyon Road in the town of Calabasas.
The two-story ranch house had its own water well and a meat storage shed
with a separate entrance. Alonzo Morrison built this family home on
4,000 acres of oak-studded hills that he used for cattle grazing. In
later years, the land was subdivided into smaller ranches and housing
developments. The main ranch house and some cattle remain on what is
left of the original property. In 1941, the 20th Century Studios
made a movie here called "Belle Starr," featuring Gene Tierney,
Randolph Scott and Dana Andrews. During filming, as called for in the
script, the studios burned down one of the barns on the property.
From 1965 to 1975 the Morrison Ranch was used in the TV series
"Gunsmoke," starring Jim Arness and Dennis Weaver.

(Oil 24" x 30")

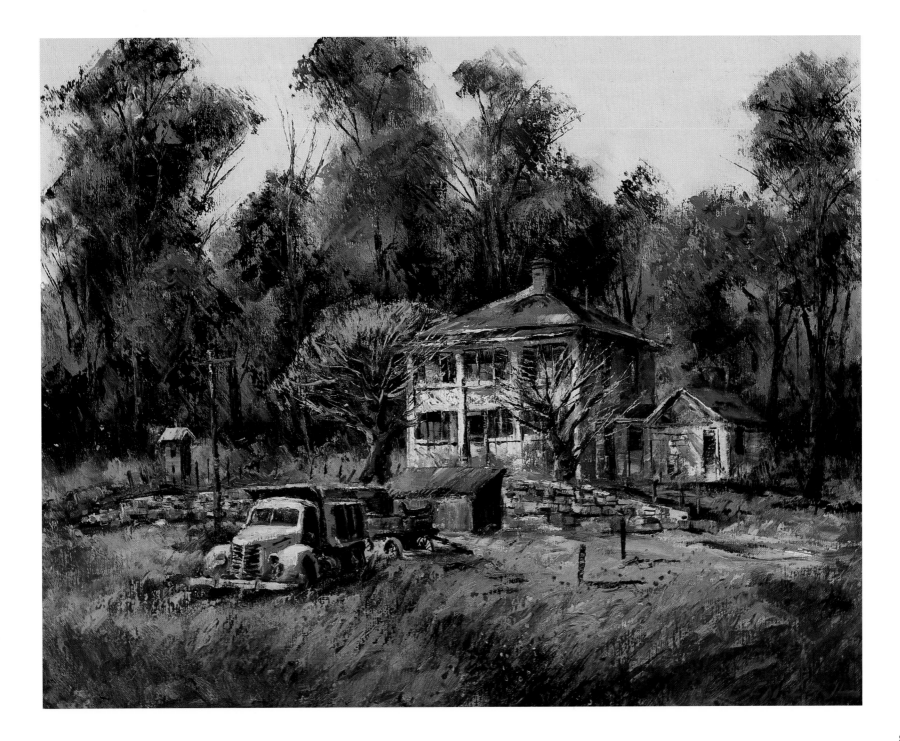

Mission San Gabriel Arcangel

The mission church, San Gabriel Arcangel, was founded in 1771 by Padres Pedro Benito Cambón and Angel Fernández de la Somera. It is one of a string of 21 missions constructed along the California coast stretching for 600 miles from San Diego to San Francisco. The San Gabriel Mission, fourth to be built, was one of the most productive of them all. Grain, fruit trees, grapes, soap, tanned hides and over 50,000 gallons yearly of the best wine then available, was produced. It served a population of over 100,000 Indians. It was from this mission that a small party of colonists set out and founded the city of Los Angeles. The Mission church is magnificent with its Moorish style architecture built with a stone base and 5-foot thick adobe block walls. It has 12 slender capped buttresses. Boasting six bells in a side campanario, the bells have rung daily for over 150 years. The largest of the bells, which weighs one ton, could be heard distinctly in the *Pueblo* of Los Angeles eight miles away.

(Oil 24" x 30")

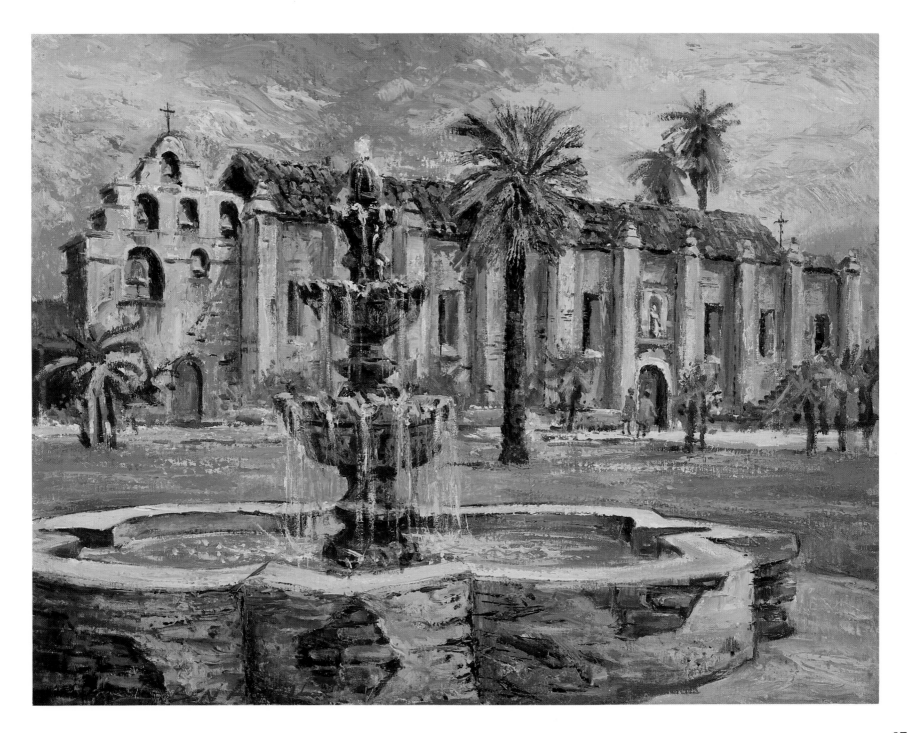

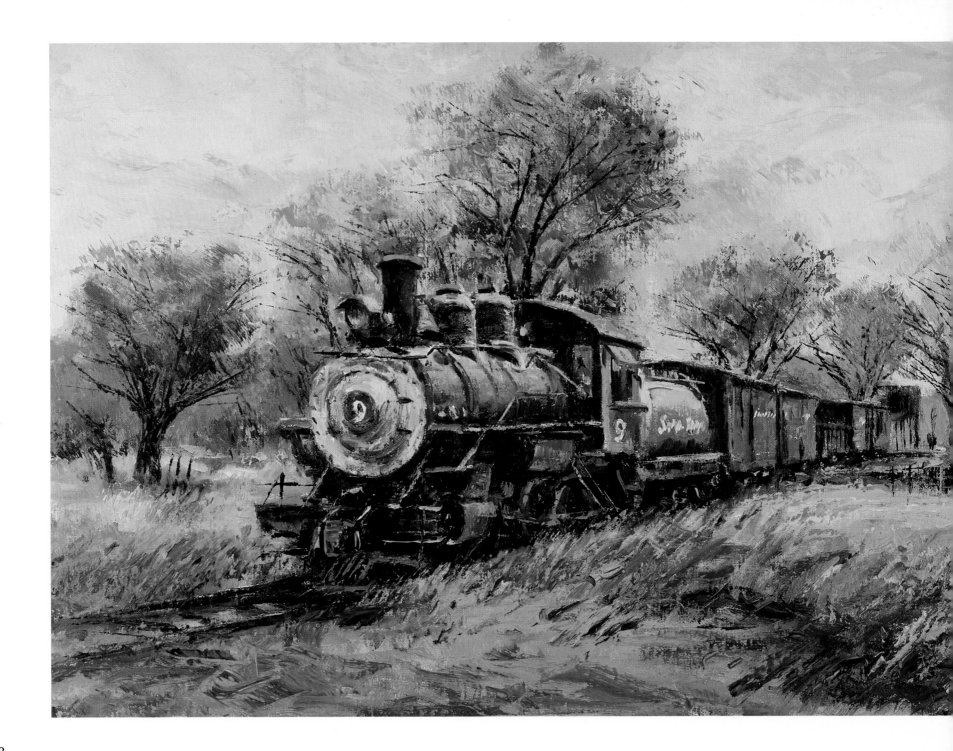

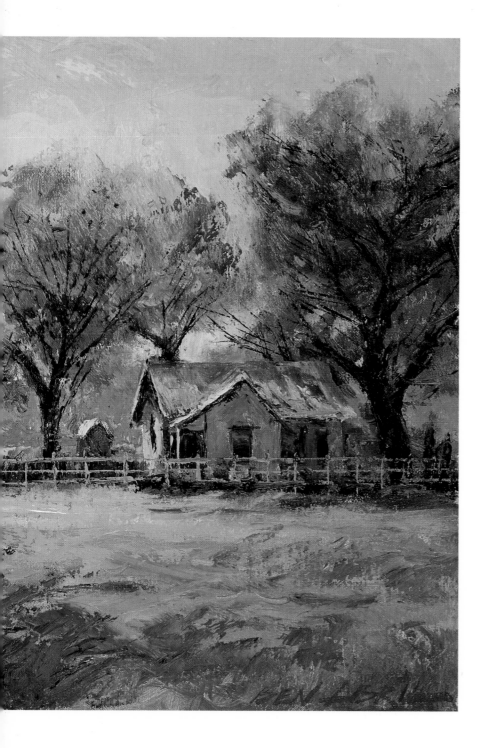

The Slim Princess

The sleek steam engine called the "Slim Princess" has come to its final resting place in the small town of Laws. In 1883, she chugged along a narrow gauge line built by the Carson and Colorado Railway Company which ran from Keeler to Mound House, Nevada. The railroad ran along the base of the Sierra Nevada mountain range and through the town of Laws, originally known as Bishop Station. Operated by the Southern Pacific Lines, the train carried cattle, sheep, gold, silver, the U.S. mail and Wells Fargo baggage. It also hauled supplies and equipment for the building of the Owens Valley Aqueduct, which was to later furnish water to the city of Los Angeles. On April 30, 1960, the "Slim Princess" made its last run. It remains today rusting on the tracks next to the Southern Pacific agent's house. In 1965, Paramount Studios used the site for the filming of "Nevada Smith," starring Steve McQueen.

(Oil 18" x 36")

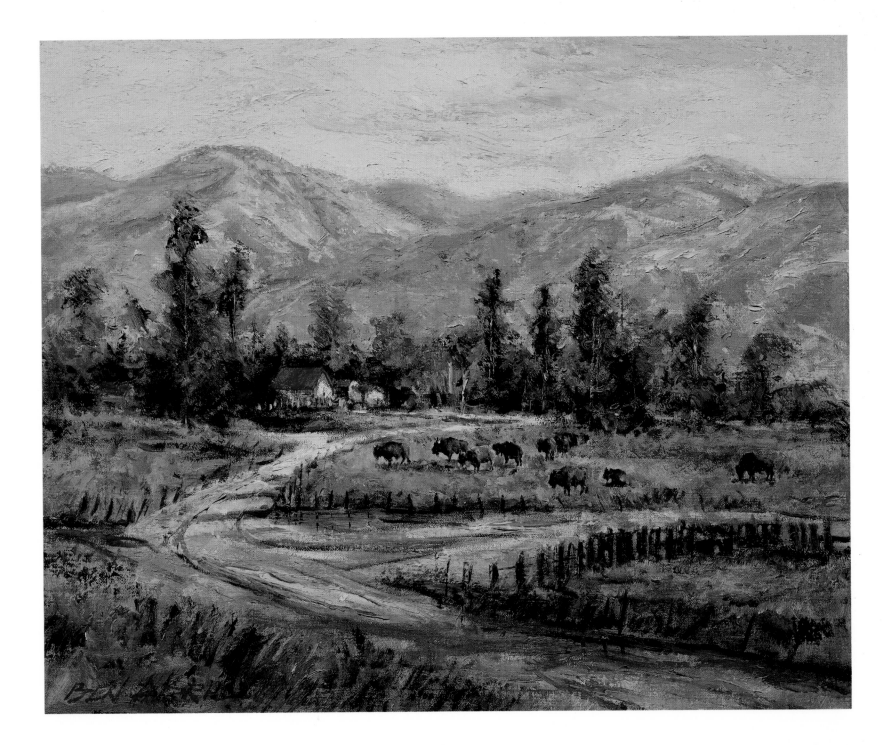

Griffith Ranch

The Griffith Ranch was located near the San Fernando Mission at the west end of the San Gabriel Mountains. Originally part of the San Fernando Mission lands, the ranch was purchased in 1912 by David Work Griffith, a revered pioneer of silent motion pictures. The ranch provided the locale for many early western thrillers, including "Custer's Last Stand," and was the inspiration for the production of "Birth of a Nation," a 1915 film starring Lillian Gish. In 1948 the property was acquired by Fritz B. Burns, who has perpetuated the Griffith name in memory of the great film pioneer. Most of the original ranch has been subdivided into small industrial buildings and some horse property. A small herd of buffalo remain on the "R.G. Bar Spread" at the north end of the original Griffith Ranch.

(Oil 20" x 24")

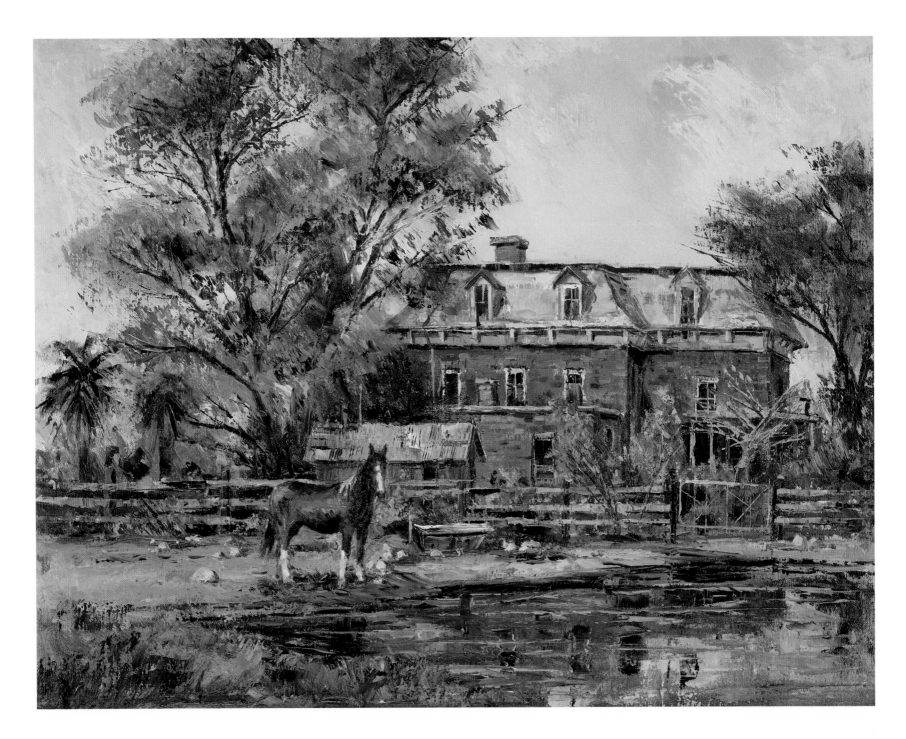

Dr. Ben Barton's House

This red brick house was built near Redlands by Dr. Benjamin Barton in 1867. He was a pioneer San Bernardino physician and operated the first drug store and post office in town where mail was delivered by stage coach. Dr. Barton came to California in 1854 with his wife Eliza. They bought an adobe house on the nearby Mission Asistencia property, while their large home was being built. He was very active in civic affairs and was elected to the State Assembly in 1861. He was also a historian for the County of San Bernardino and several of his letters are on file in the Bancroft Library at the University of California. In 1889 he moved from his red brick house to a palatial mansion in San Bernardino. In later years, Barton's son became mayor of San Bernardino.

(Oil 24" x 30")

Sutter Creek

The gold town of Sutter Creek in Amador County was named after John Augustus Sutter, the first white man to enter the region of central California near the present town of Sacramento. In 1839 he settled along the American River and started farming a 48,400 acre land grant given to him by the Mexican government. He was also given the power to enforce California laws. To protect his land, he built a fort with 15 foot high walls, placing cannons at the corners. It was at this fort that he entertained the first United States exploring party led by John C. Fremont and his guide Kit Carson. In 1848, Sutter hired James Marshall to build a sawmill for him on the banks of the American River near Coloma. It was during the construction of the mill that Marshall discovered quartz gold. Within days of the discovery, the news was out and the great California gold rush was on. With the insurgence of thousands of men to the area, Sutter lost much of his land to squatters. In 1852 his Indian workmen deserted him and he eventually went bankrupt. He returned to his former home in Pennsylvania, where he died impoverished in 1880.

(Oil 24″ x 30″)

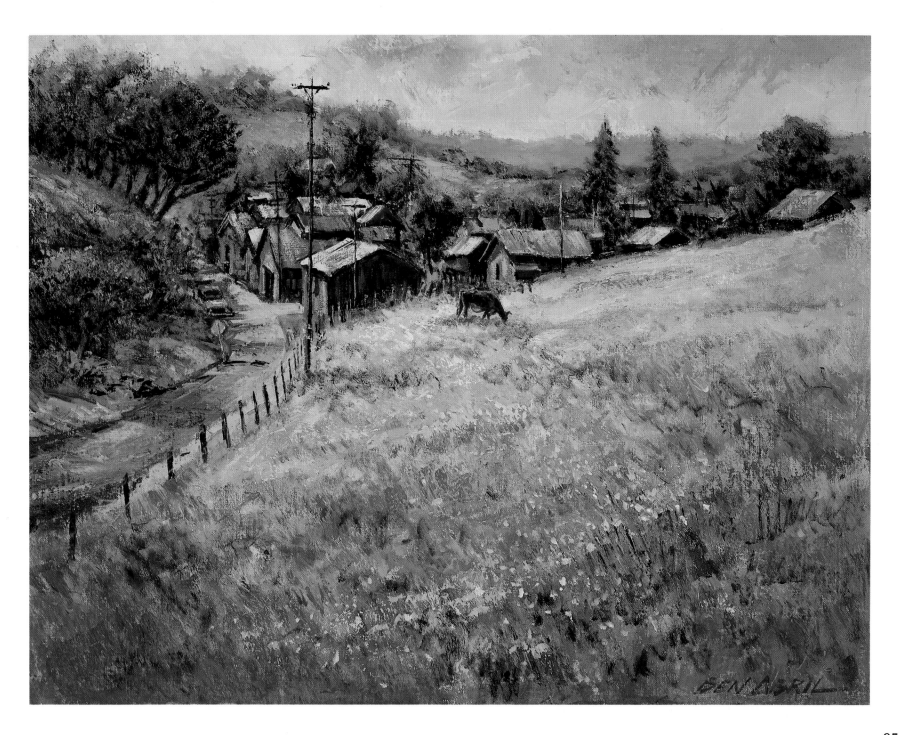

95

Lake Mary at Crystal Crag

In 1891, George Calvert ran a gold mining camp at Pine City in the Mammoth Lakes area of the High Sierra Mountains. He named Lake Mary, located near Pine City, after his wife Mary Calvert. Other early mining camps in the area were at Mammoth City and Mill City. In those early days, miner's tents were strung along the streams around Lake Mary and the adjacent Lake George. Dog teams hauled freight from Sherman Summit to Mammoth Mountain for ten cents a pound, passengers at twenty dollars a head. The large peak towering above Lake Mary was called the "Crystal Crag" by the early miners. Snow remains in this alpine region of California most of the year.

(Oil 24" x 36")

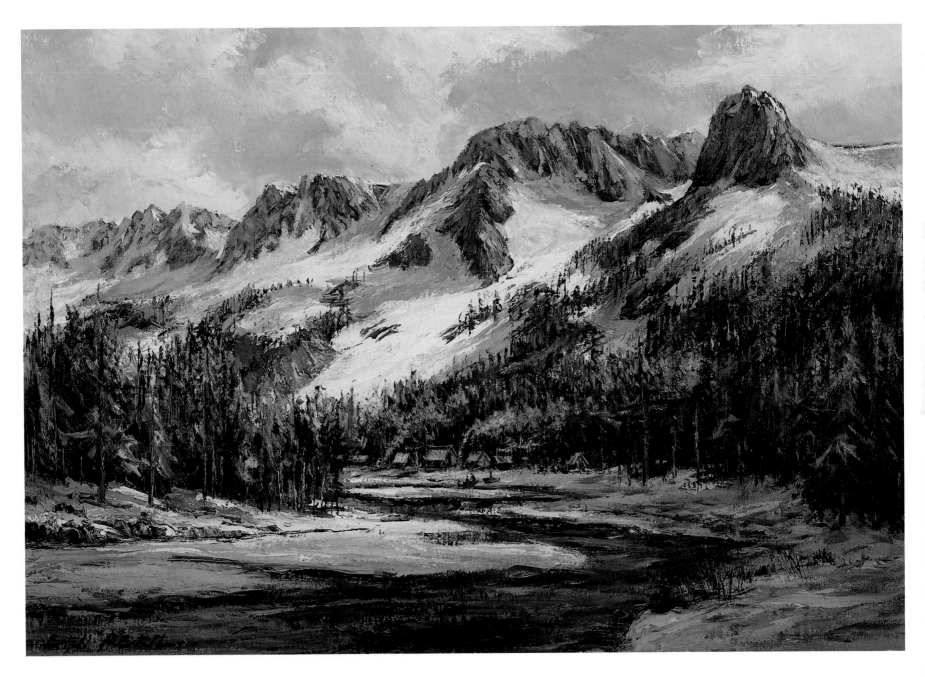

Russian Outpost

This sturdy wooden fort, known as Fort Ross, was built in 1812 by a Russian fur company led by Ivan Kuskov. He, along with 25 Russians and 80 Alaskan Aleuts, came ashore on the Sonoma Coast of northern California near the present town of Jenner. Their purpose was to hunt sea otter and grow wheat and other crops for their Russian settlement in Alaska. The fort which overlooked the sea had cannons protruding from the corner blockhouses. Inside the stockade they built commandants quarters, several houses and a Greek Orthodox chapel. After 29 years of hard work, the Russians became discouraged with their venture because of a depleted sea otter population and failed crops. In 1841, Alexander Rotchev, the last commander of the fort, reached an agreement and sold the fort and all of its improvements to Captain John Sutter and returned to Alaska. The state of California acquired Fort Ross in 1906 as an historical landmark.

(Oil 18" x 24")

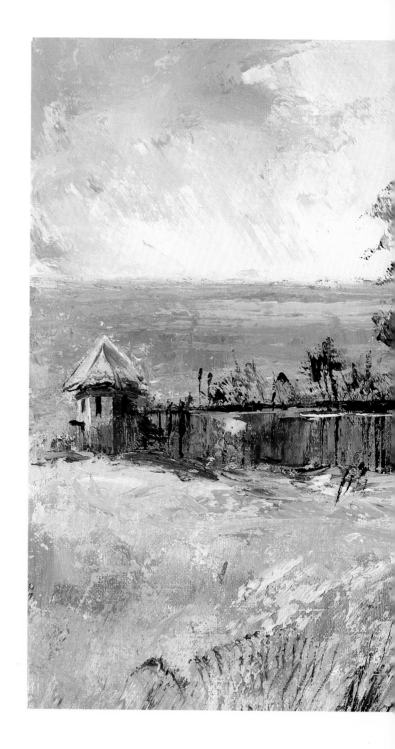

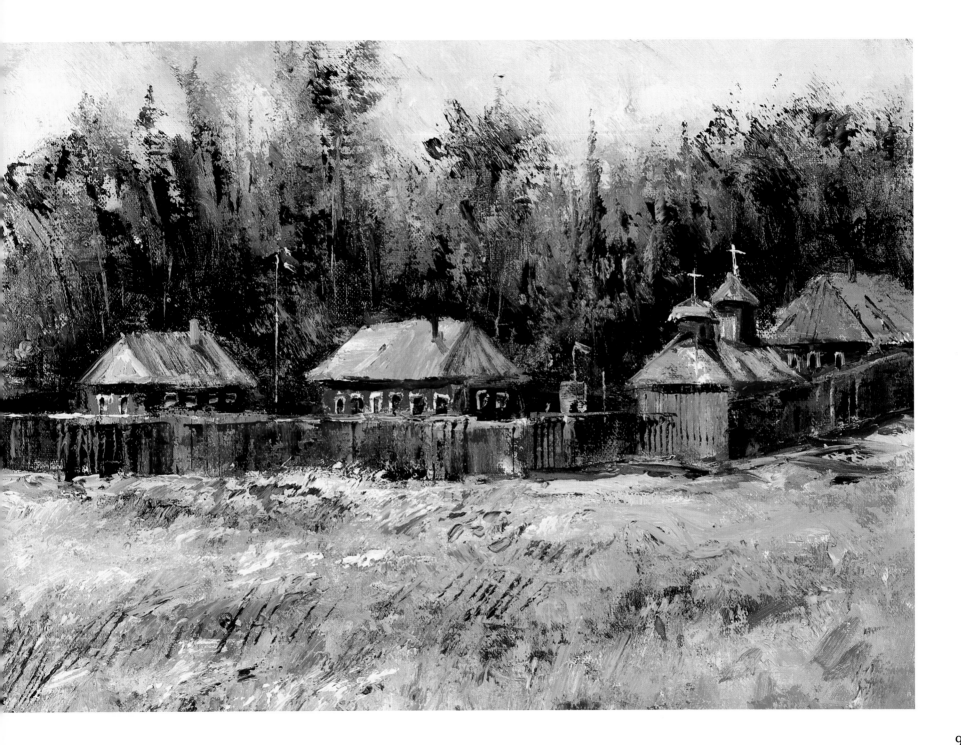

First Nevada City Firehouse

This red brick firehouse with its Victorian bell tower and gingerbread trim was built in 1861 on a hillside near the banks of Deer Creek in the historic California gold mining town of Nevada City. At the beginning, this volunteer fire department used man-powered hose carts and later a stable of horses was added to the rear of the firehouse. In 1864 it became the headquarters of the Nevada City Hose Company No. 1. The hose company relocated in 1938 and the building became a museum for the Nevada City Historical Society. Today, it houses one of the finest collections of memorabilia of the early gold mining days.

(Oil 18" x 24")

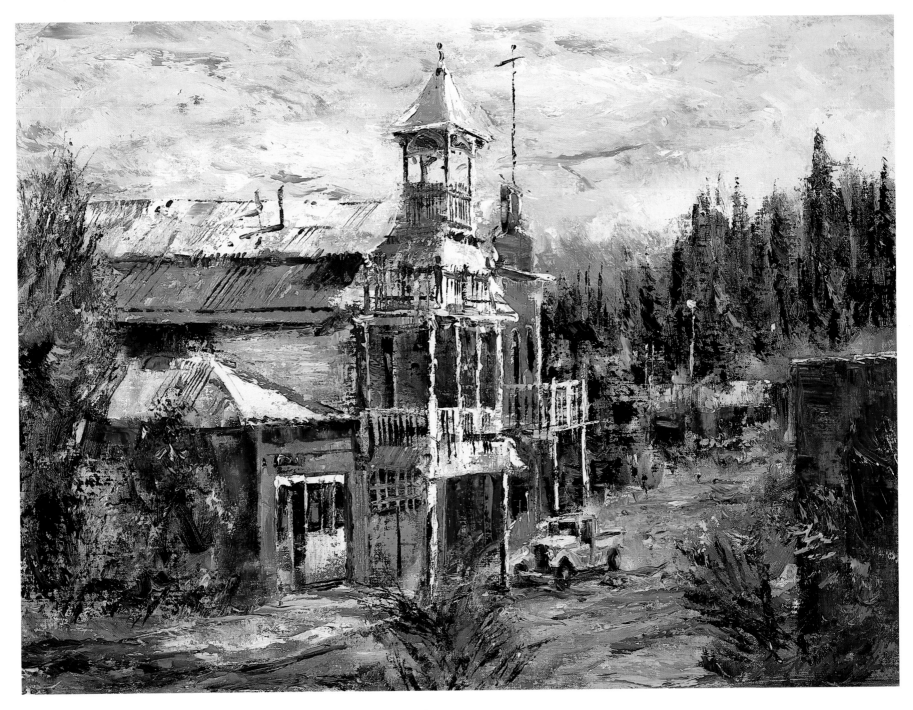

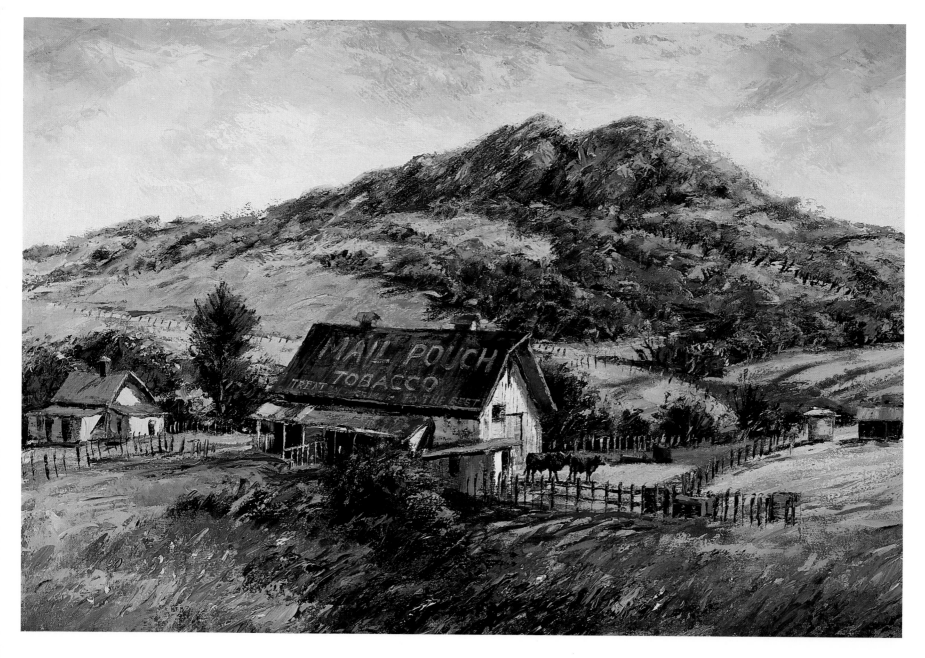

Mail Pouch Dairy Barn

The inscription on the roof of this picturesque barn reads: "Mail Pouch Tobacco — Treat Yourself to the Best." This fleeting glimpse of yesterday has a strong appeal for many passing motorists. This "Mail Pouch" dairy barn, located on the outskirts of San Luis Obispo, is one of the most photographed barns in California. Built by James Rasmussen in 1895, the weathered barn stands beneath the towering Bishop Peak on the road to the famous Hearst Castle in San Simeon. The house next door was built by Mr. and Mrs. Hansen, an early pioneering couple, who acquired the barn and 220 acres of surrounding property for raising dairy cows. In the old days, tobacco companies would offer to whitewash barns and as payment for this service, they were allowed to paint the advertisement on the roof.

(Oil 30" x 48")

Old Potter School

The Potter School, built in 1873, is located 50 miles north of San Francisco in the town of Bodega. This school was one of the settings used in the 1963 thriller movie, "The Birds," directed by the master of suspense films, Alfred Hitchcock. Suzanne Pleschette, Tippi Hedren and Rod Taylor played the primary roles in the film. During the filming, Alfred Hitchcock would arrive daily from San Francisco in a chauffeur driven limousine to direct the movie, while most of the cast and crew roomed in Bodega Bay. Many of the local townspeople were thrilled to act as "extras" in the crowd scenes. Today, the school building is still an historic stopover for the curious traveler who remembers "The Birds."

(Oil 18" x 24")

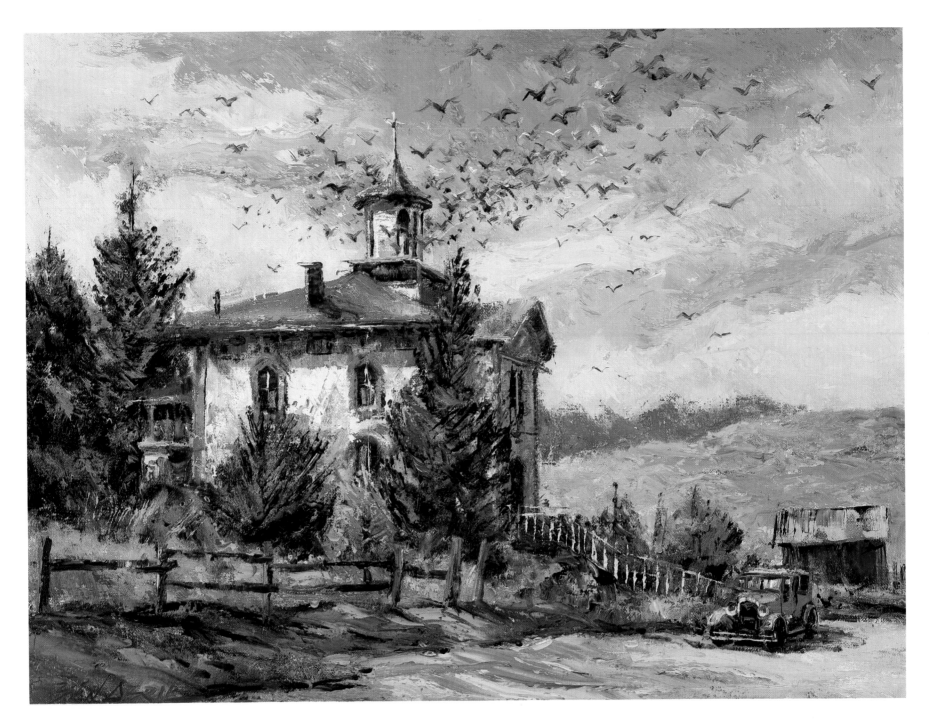

The Dinky

I found this little red trolley car No. 331 rusting in the grass at the Orange Empire Railway Museum. Because of its small size it was nicknamed "The Dinky." It was built in 1918 by the Burny Coach Company for the Pacific Electric Railway system in Los Angeles. In 1943, after 25 years of serving the public, "The Dinky" was sold to the MGM Studios for use in movies. It became a "Hollywood star" when Gene Kelly danced on its roof in the movie, "Singing in the Rain." Some years later, "The Dinky" was donated to the Orange Empire Railway Museum. This fine museum, located near the town of Perris, has over 120 pieces of rolling stock which includes electric trolley cars, antique busses and a few steam train locomotives. The 50-acre museum is privately run by over 2,000 members, mostly railroad buffs.

(Oil 18" x 24")

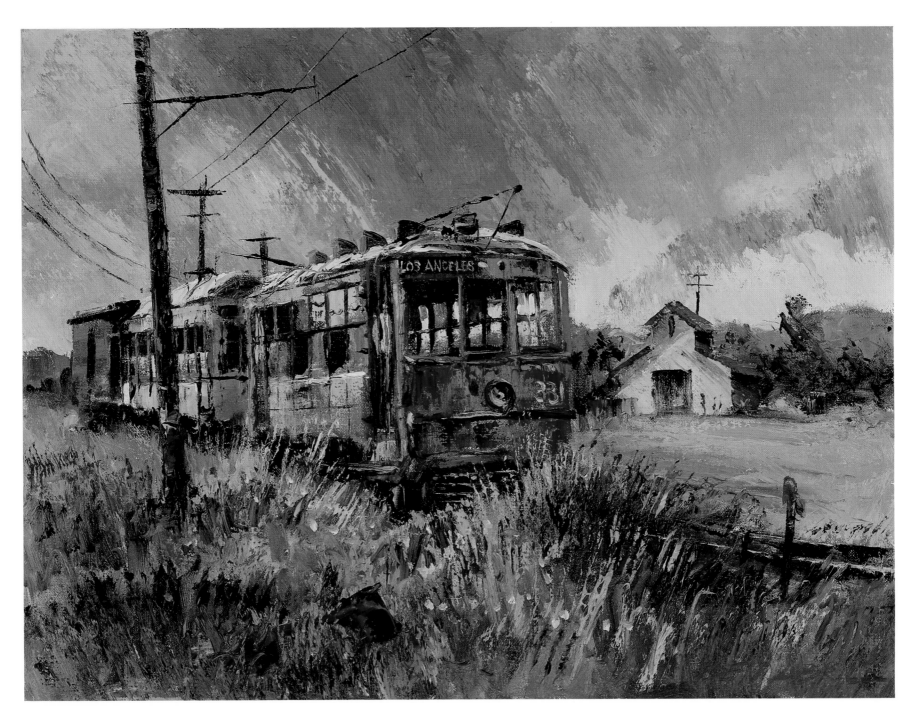

Casa de Don Geronimo Lopez

This house was built by Geronimo Lopez in 1882 and is the oldest two-story abobe brick structure in the San Fernando Valley.

Lopez played an important role in California history. On January 11, 1847, as a sixteen year-old messenger in the Mexican Army under the direction of General Andres Pico, he carried the flag of truce and letter of surrender from the General to John C. Fremont, Commander of the American troops camped near Newhall. This meeting resulted in the signing of the "Cahuenga Treaty," thus ending the Mexican War in California. Additionally, the United States gained the territory of the American Southwest, including all of California. After the war, Lopez took up ranching in the San Fernando Valley on 40 acres of land that he purchased from a mission Indian. He opened the first general store, post office and stage stop near the San Fernando Mission. Lopez and his wife, Catalina, raised their 13 children in the adobe house and he died there at the age of 91.

(Oil 20" x 30")

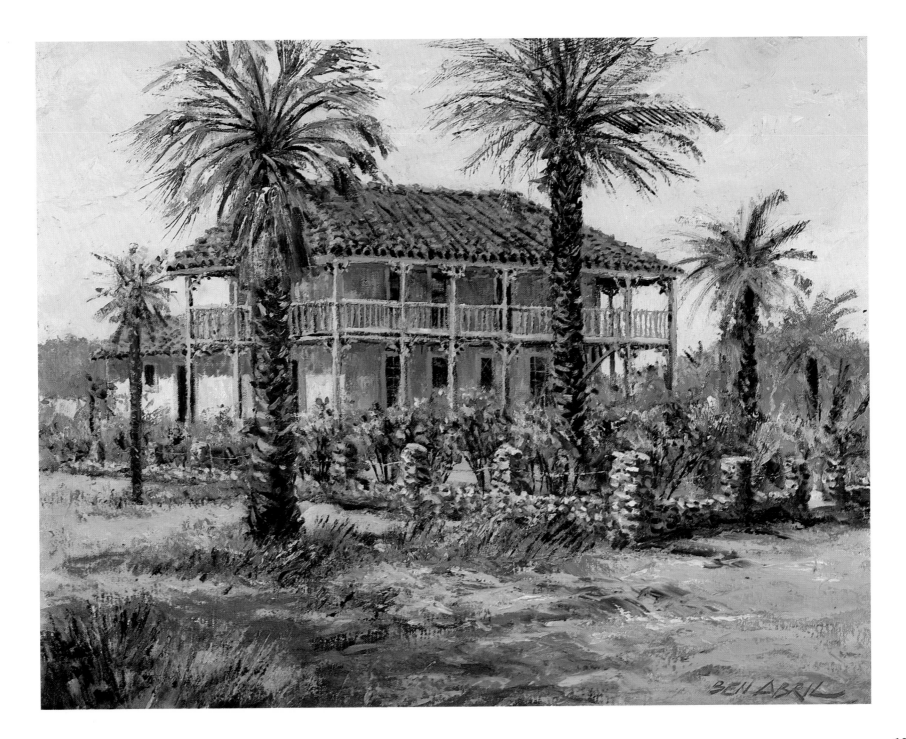

San Carlos Borromeo de Carmelo

The Carmel Mission, established by Father Junipero Serra on June 3, 1770, was first constructed at the bay of Monterey and later moved to this picturesque Carmel site along the mouth of the Carmel River. It was the second of the missions to be founded. Overlooking the sea, it was Father Serra's favorite and was used as his headquarters while managing the growing mission chain. He died in Carmel at the age of 71 and is buried in the mission church at the foot of its high altar. Mass is still said daily by diocesan parish priests. The Moorish influence of the architecture and its surrounding beautiful gardens, make it an outstanding California historic landmark.

(Oil 20″ x 30″)

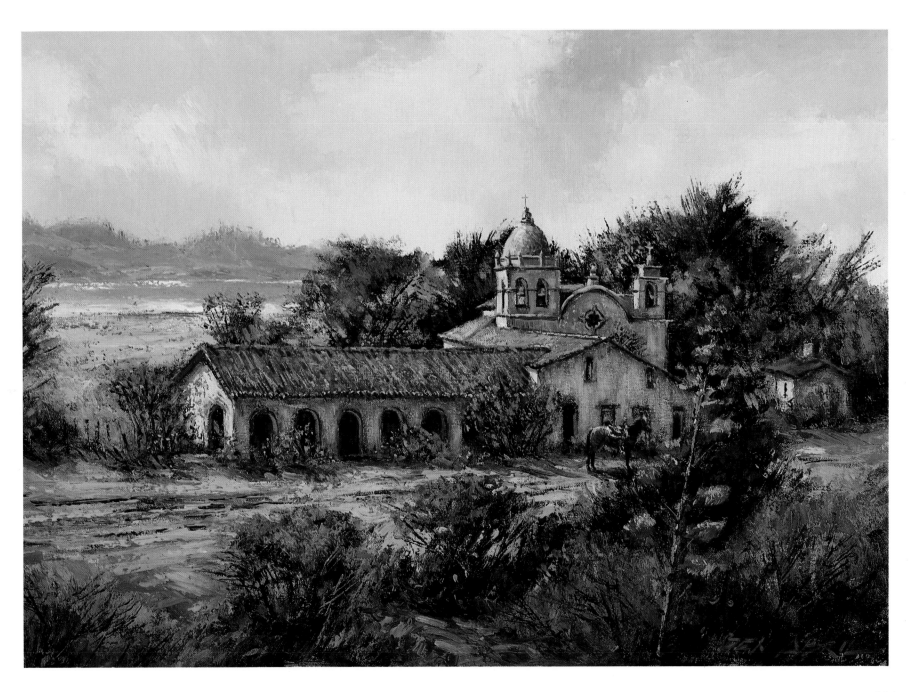

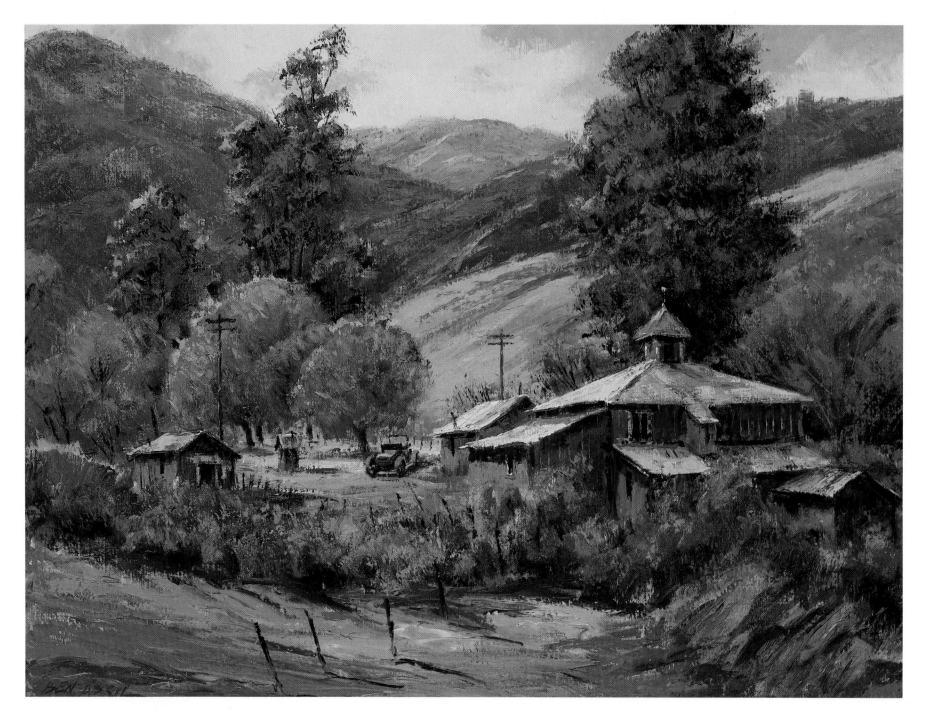

Barn at Mentryville

This tin-roofed red barn, nestled in the hills near Newhall, is known
as the Mentryville Barn. In 1875, C.A. "Alex" Mentry arrived in
Newhall from Pennsylvania. A mining engineer of sorts, Mentry, using
an improved drilling method, redrilled an existing oil well which
hit a bonanza of 120 barrels a day. With this new oil wealth, Mentry
purchased the town of Pico Springs and renamed it Mentryville.
Nearby, where the barn now stands, Mentry built a large two-story
white frame house which became the family home. Also in the cluster
of buildings, is a one-room schoolhouse that was built by the
towns people and named "The Felton School." After several years
the Standard Oil Co. purchased the town and surrounding land from
Mentry. The last class in the school was held in 1932, after which
the town was abandoned. The buildings are watched over by caretakers
and once a year, a reunion of alumni and an ice cream social is held
at the town by the Santa Clarita Historical Society.

(Oil 30" x 40")

Calico Mining Camp

From 1881 to 1896, the desert mining camp of Calico, located near Yermo, produced over 85 million dollars in silver. This made Calico the largest producer of silver in California. As the town of Calico grew, saloons, stores and a schoolhouse were built for the 3500 inhabitants. The sheriff of San Bernardino owned the largest mine in the area. Known as the "Silver King," this mine brought in over 10 million dollars during its hey day. At the turn of the century the price of silver dropped so low that it was no longer profitable to run the mines. Slowly the area was abandoned and Calico became a ghost town. In 1950, Walter Knott purchased the entire town and worked on its restoration until 1966, when he donated it to the county of San Bernardino. Today the Calico mining camp is an historical landmark where its colorful history and past glory can be seen by all.

(Oil 20" x 30")

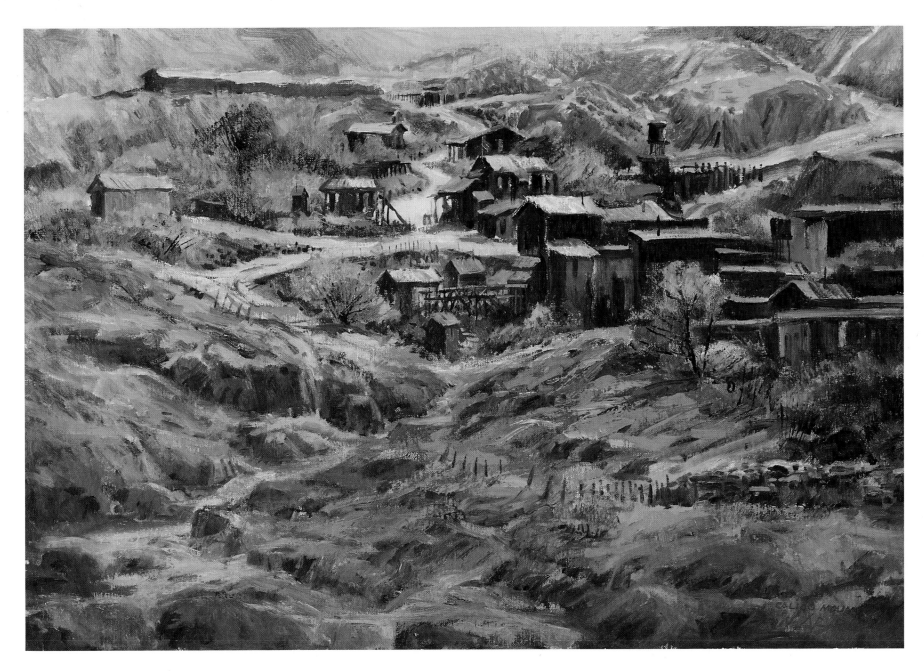

About The Artist

Ben Abril is an impressionist landscape painter who has joyfully dedicated his life to his art form. Making an indelible mark on the art world, he has achieved international fame and recognition through numerous one-man gallery shows, art awards, museum exhibits, and paintings that hang in private and public collections.

An energetic and prolific artist, who prefers painting out-of-doors in a natural setting, landscapes have been his passion. Using bold strokes of primary colors with brush and palette knife, he captures the heart and soul of his subjects with a poetic sensitivity which transcends the canvas.

California is Abril's territory and a source of boundless inspiration. With easel and paintbox tucked under his arm, no road has been too busy or lonely for him to explore. His brush has recorded nostalgic Los Angeles scenes such as Angels Flight and Bunker Hill with its old Victorian mansions, salt-box cottages, and bungalows. Meandering country lanes have led him across streams and oak-studded hills to abandoned stage coach way-stations, weather-beaten barns, and the gold camps of the Forty-Niners.

"After forty years of painting, I feel that I am the California landscape," Abril says. And indeed he is. He was born in Los Angeles on April 11, 1923. The son of a carpenter, Abril remembers the depression years when jobs and money were scarce, his father would help him make toys out of scrap wood pieces that were brought home.

His mother, who studied landscape painting in her spare time, lovingly nurtured his budding drawing talent. Each Sunday was an eagerly anticipated day for both mother and son, as she would sit patiently by his side while he copied cartoon characters from the comics. "My favorites were Pop-Eye, Jiggs, Buck Rogers, and Mickey Mouse. I wasn't very good, but I was learning," Abril states.

Learning how to draw well became an obsession for the young Abril and throughout his school years he excelled in art classes. Upon his graduation from Glendale High School in 1941, war clouds were gathering over Europe. As the United States involvement in the conflict was eminent, and with the nation's war preparations escalating, Abril set aside college plans to work as a riveter on fighter planes at Lockheed Aircraft Company in Burbank. This first job was of a short duration for he was soon drafted into the Air Force.

Upon completion of basic training he volunteered to be a tail-gunner on a B-24 bomber. When he received his wings, he was assigned to the 714th Bomb Squadron in Norwich, England. Abril made his entrance into the "European Theatre" aboard the luxury liner, "Queen Elizabeth," which had been converted into a troop transport carrier.

After unsuccessfully battling severe air sickness, he was reassigned to an aircraft armament

Ben's parents, Sarah and Ventura, with Cardinal Manning at the San Fernando Mission

Ben accompanied by his daughters, Debbie and Lori, with Chief Iron Eyes Cody, Santa Ynez Indian Reservation, 1973

ground crew in Ipswich, where he spent the next two years. It was here that he first saw the paintings of Constable and Gainsborough, England's most famous landscape artists. "This was a pivotal time in my life, for my eyes were opened to the beauty of landscape painting," he states.

At the war's end, he marched home to marry his high school sweetheart, Dorothy Mae Kelley. With the inspiration sparked by English landscape masters, Abril decided to become a serious art student.

He began his study at the Glendale School of Allied Arts under the direction of Stan Parkerhouse, a former New York illustrator and protege of the well-known artist, Dean Cornwell. Although trying his hand in mixed mediums, watercolors became his favored choice of expression, under the tutelage of noted Naval artist Arthur Beaumont.

Abril went to work for the Glendale Post Office after completing his first year of art school. By

accepting night shift hours, he was free to go to school and paint during the day. In those days, painting was far more important than sleeping.

The next three years were devoted to honing his craft as a watercolorist, as well as developing his on-the-site *Alla Prima* technique of completing a painting in one working session.

Abril's long-striding, paint-spattered figure became a familiar one as he commandeered a sidewalk position to paint the ever-changing vignettes of Los Angeles' old Chinatown.

Always intrigued by trains, he became a regular around the railyards. Often he would attract a gathering of itinerant men of the rails who were not at all bashful about giving him their two cents worth of direction. "After analyzing their suggestions, I was surprised that some of their critique was quite good," he recalls.

This railyard background proved to be a valuable reference when in later years, he illustrated three childrens books about trains for the Follett Publishing Company in Chicago. In

Ben with Hollywood personality Don Defore, Cowie Galleries, 1967

Ben Abril and present California Attorney General, John Van de Kamp

total, the publisher bought 75 of Abril's watercolors.

When "The Greatest Show on Earth" came to town, Abril was always there in the midst of the excitement as the big circus tents went up. Never lacking subject matter to paint, Abril and his easel were a magnetic attraction as curious circus folk would come to peek over his shoulder as he worked.

One of the most interested onlookers was a daring individual who was billed as "The Human

Actor and Art Collector Vincent Price with the Artist

Ben and his wife, Dorothy, with Mr. and Mrs. Clarence Myerscough, Challis Galleries, 1972

Cannon Ball." He too was an artist, and when he wasn't being shot out of a cannon, he and Abril would swap trade secrets and paintings. But it was to the "Fat Lady," who was married to the "Thin Man," that he sold one of his first paintings — and for the whopping sum of $5.

With an insatiable desire for knowledge and to stretch his artistic wings, Abril continued his formal art training which included study at Glendale College, Otis Art Institute, Art Center College of Design, and Chouinard's School of Art.

While following his unwavering path towards becoming an accomplished painter, Abril never fell to the lot of being a "starving artist." Blessed with an incredible energy source, he always found a way to not only support his art, but also a growing family of three children.

Managing to find time to squeeze in architectural classes into his schedule of art study, Abril prepared for his bread earning future. He was hired by the County of Los Angeles, first as a cartographer, and eventually as a color consul-

United States Navy Rear Admirals King, Garrick, and Lyon with the artist, Hollyhock House, 1965

tant in architectural design.

At the completion of an 8 to 5 working day, he would spend his evenings engrossed in fine art painting, often into the wee hours of the morning. "No matter how well I thought I had executed a painting, I was always striving to improve," he says. Working with the county for 20 years, he opted for an early retirement in order to paint full-time.

In his early painting years, Abril had chosen watercolors as his primary medium of expression. As his focus became more directed towards the painting of landscapes, he began working with oils. The transition was not only a challenge to his painting skills, but an exciting new dimension to explore. The depth and texture he achieved by using his palette knife gave his paintings a new strength and impact.

His first one-man show at the prestigious Cowie Galleries in Los Angeles, including both watercolors and oils, catapulted him from an unknown painter into the forefront as an up-and-coming California artist. Since that first outing at the Cowie, the list of his one-man exhibits in galleries and museums around the country is an impressive one.

Initially, being a recognized and sought after artist evoked mixed feelings within Abril. He was thrilled that his work was selling, but the emotional attachment to his paintings was so strong it was difficult to release them. "I felt my

paintings were like my children, they were born of my creativity, I nurtured them, but it was painful for me to let them go out into the world," he shares. Fortunately for the many Abril collectors, this was a short-lived period.

He remembers well his first major buyer. Vincent Price, the renowned actor and art collector, upon seeing his work at a gallery, asked to come to his studio. The impending celebrity's visit sent the Abril household into a heightened state of excitement.

"I felt honored and nervous because he was such a famous person and I wanted everything to be perfect," Abril remembers. Just moments before Price was due to arrive, he was horrified to see a large gathering of neighbors, with autograph books in hand, standing on the front lawn. The news of the famous visitor had evidently been leaked by the Abril children, but at this point there was nothing that could be done about it.

When Price arrived, Abril said that he graciously greeted the neighborhood fans and signed their books. "After apologizing for the uproar, I showed him my paintings. Much to my amazement he bought 37 paintings, everything that I had in the studio," he recalls.

Abril's paintings are in the private collections of well-known people such as former President Richard M. Nixon, Caroline Kennedy, and California Governor George Deukmejian. His paintings also hang in a myriad of corporate collections and Los Angeles city administrative offices.

Nominated to "Who's Who in American Art," Abril's paintings are in the permanent collections of seven museums, including the Frye Museum in Seattle. One of the most memorable acknowledgments of his talent was a long-running exhibition of his Bunker Hill oils at the Los Angeles County Museum of Natural History.

Ben Abril teaching a class in Pasadena

122

The historical importance of this large body of paintings, of which the museum bought 35 for a permanent collection, was significant. Soon after Abril had recorded the fading glory of these once magnificent houses, bulldozers eradicated forever this glimpse of old Los Angeles.

Abril's talent has also been recognized in the nation's capital. He was commissioned by the U.S. Navy to spend a month in Japan painting an unclassified art series. Today seven of his paintings from that commission, depicting American naval installations during the time of occupied Japan, hang in the U.S. Navy Combat Art Collection in Washington, D.C.

His paintings were so well received that he was asked to take a second assignment, with the honorary rank of Captain, to paint in the Mekong Delta region of Vietnam. This was a singular honor as it was the first time an artist had been asked to carry out two major assignments.

Another commission which Abril felt very honored to complete, was a request to do a painting of the Los Angeles Memorial Coliseum. A reproduction of this painting was used on an opening ceremonies luncheon invitation addressed to the heads of state of the 140 countries competing in the XXIII Olympic Games.

In summarizing his painting career, Abril says, "I am thankful for my good fortune and recognition in the art world. I still enjoy painting out-of-doors in a natural setting, for the sake of

Debbie, Dana, Ben, and his father, Ventura, at the Biltmore Galleries, 1972

art alone. May the hand of God never still my brush, until I have completed that one masterpiece of my dreams," he concludes.

Ben Abril lives with his wife Dorothy in La Canada Flintridge, a wooded foothill community 15 minutes from downtown Los Angeles. Their three young adult children, Dana, Deborah and Lori, live nearby.

— Jane Napier Neely

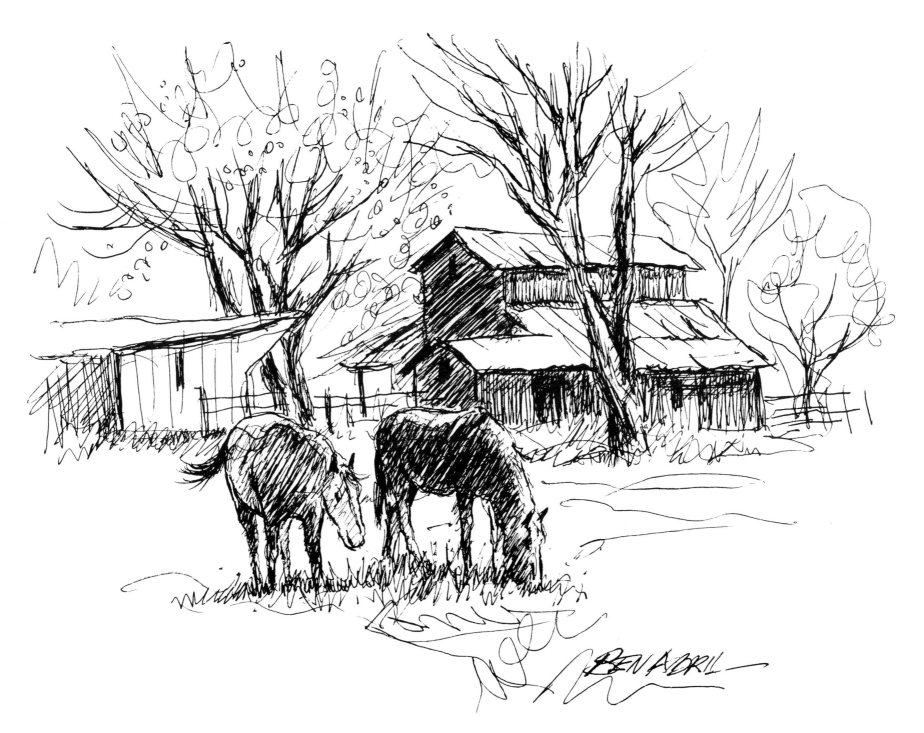

The greatness of an artist or a writer
does not depend on what he has in common
with other artists and writers, but on what
he has peculiar to himself.
Alexander Smith

PRINTING BY VON PLATER GRAPHICS/LARRY BROWN LITHOGRAPHERS
TYPOGRAPHY BY THE PROSPERITY PRESS
BINDING BY WEBER-McCREA
GLENDALE, CALIFORNIA